Exhibit Makeovers

Exhibit Makeovers

A Do-It-Yourself Workbook
for Small Museums

ALICE PARMAN AND JEFFREY JANE FLOWERS

ALTAMIRA
PRESS

A Division of
ROWMAN & LITTLEFIELD PUBLISHERS, INC.
Lanham • New York • Toronto • Plymouth, UK

AltaMira Press
A division of Rowman & Littlefield Publishers, Inc.
A wholly owned subsidary of The Rowman & Littlefield Publishing Group, Inc.
4501 Forbes Boulevard, Suite 200
Lanham, MD 20706
www.altamirapress.com

Estover Road
Plymouth PL6 7PY
United Kingdom

British Library Cataloguing in Publication Information Available

Library of Congress Cataloging-in-Publication Data

Parman, Alice, 1942–
 Exhibit makeovers : a do-it-yourself workbook for small museums / Alice Parman and Jeffrey Jane Flowers.
 p. cm.
 ISBN-13: 978-0-7591-0996-4 (cloth : alk. paper)
 ISBN-10: 0-7591-0996-6 (cloth : alk. paper)
 ISBN-13: 978-0-7591-0997-1 (pbk. : alk. paper)
 ISBN-10: 0-7591-0997-4 (pbk. : alk. paper)
 1. Museum exhibits—Handbooks, manuals, etc. 2. Small museums—Handbooks, manuals, etc. 3. Museum exhibits—United States—Handbooks, manuals, etc. 4. Small museums—United States—Handbooks, manuals, etc. I. Flowers, Jeffrey Jane. II. Title.
 AM151.P37 2008
 069'.5—dc22 2007033961

Printed in the United States of America

∞™ The paper used in this publication meets the minimum requirements of American National Standard for Information Sciences—Permanence of Paper for Printed Library Materials, ANSI/NISO Z39.48-1992.

Contents

Exhibit Makeovers

LET US START BY INTRODUCING OURSELVES TO YOU. ALICE Parman began her museum career as an educator and administrator at Chicago's Field Museum in 1973. Since then, she has been director of two small museums, planner/writer for an exhibit design firm, and (since 2003) an independent consultant to small museums. Jeffrey Jane Flowers is a graphic designer who has worked for a wide variety of corporate and institutional clients since 1982. Her work has ranged from publication and special event design in Baltimore, Maryland, to the development of a small museum gallery on Pohnpei, in the Federated States of Micronesia.

Along the way, it has been our good fortune to be involved—as visitors, planners, designers, or volunteers—with high-quality, popular exhibits that were planned, designed, and mounted for a few thousand or a few *hundred* dollars—or even less.

We've noticed that the most successful exhibits grow out of thoughtful planning, energetic execution, and a spirit of openness and collaboration. We're convinced that these factors are far more important than the size of your budget, or the extent of your exhibit design experience.

In that spirit, we offer *Exhibit Makeovers* as a resource for affordable, do-it-yourself exhibit development.

WHAT'S AN EXHIBIT MAKEOVER?

As shown in television shows and magazine articles, a makeover starts with something that exists: a face, a room, a house, a garden. A cosmetic makeover is far less invasive and expensive than Botox injections. A home makeover is simpler and less costly than new construction.

An exhibit makeover is a do-it-yourself method for improving an existing exhibit. A makeover of a single exhibit case helps you learn the fundamentals. Then you may feel ready to tackle an exhibit gallery makeover. Eventually, you might take on a makeover of the whole museum!

WHAT'S THE PAYOFF FOR A SMALL MUSEUM?

Exhibit Makeovers is written for board members, staff, and volunteers in small museums. By "small," we mean museums with limited funding and few or no paid staff members.

Despite the small size of their budget and staff, small museums may have large collections. Their mission may encompass a sizable region, or a substantial field or discipline.

Your museum may house exhibit cases full of tools or dolls, rooms packed with farm implements or vehicles, and storerooms of eclectic objects, photos, and documents from your region. Where do you start? How do you begin the makeover process? And with your scarce resources and multiple responsibilities, why should you consider taking time to do an exhibit makeover?

Perhaps you're tired of looking at the "same old same old" and want to shake up your exhibits by the equivalent of rearranging the living room furniture.

Maybe your audience and volunteer base is growing older and sparser. You have a sneaking suspicion that unless your museum reaches out to newcomers and younger folks, eventually it will fade away from neglect.

Has a tourism or downtown redevelopment agency approached the museum to partner in a citywide renewal effort? Or has a community group asked the museum to tell their story? Perhaps a friend of the museum has offered to contribute funds for exhibit development.

Whatever your motivation for transforming your exhibits, a makeover offers significant benefits. The exhibit makeover process is dynamic, interesting, and fun. It can energize the creativity and vitality of board and staff. It can help your museum increase the number of volunteers, involve community members, and become a more valued and viable part of your community.

HOW TO USE THIS WORKBOOK

Exhibit Makeovers is a hands-on introduction to three stages of makeovers, focused on a single-case exhibit, a gallery, and finally a small museum. Along the way, you'll develop new skills and build a record of your exhibit development progress in a series of worksheets.

Exhibit Makeovers takes you step-by-step through the exhibit makeover process. Each step calls for creativity, thoughtfulness, and an open mind. You may feel that parts of the process don't apply to you, yet we encourage you to give each planning worksheet a try.

Each questionnaire, checklist, and brainstorming exercise is designed with a single overriding goal in mind: to help you view your museum and your exhibits through visitors' eyes. This is the key that will unlock your museum's potential as a community resource. Take cues from your local public library, YMCA, or community center. To attract and successfully serve a broad community audience, these institutions always put the visitor first.

Detailed instructions and open-ended worksheets help you create an exhibit project that's tailor-made for your museum. You may photocopy any worksheet in this book for use in an exhibit makeover project. Use this workbook in whatever ways best fit your institution, your community, and your planning team.

The exhibit makeover process is challenging and absorbing. It requires a serious commitment of time and energy. The effort is well worth it. The result—renewed exhibits that awaken interest and excitement among your visitors—should be deeply rewarding to all participants. Let's get started!

ASSEMBLE YOUR EXHIBIT MAKEOVER CREW

Recruit board members, staff, and volunteers to work on your makeover project. Three people are a workable number for a single-case exhibit makeover (see chapter 2 for details). For an exhibit gallery makeover, build an Exhibit Makeover Crew of 10–12 (more in chapter 4). For a museum-wide makeover, divide your crew into subgroups and involve people from the entire community (see chapter 8).

LAY THE GROUNDWORK

Whether your exhibit makeover is focused on a single case, a gallery, or the entire museum, three touchstones will guide your creative efforts: your museum's mission, the main messages you want to convey, and the amount of money you want to spend.

Each of these basic guidelines grows from the unique position of museums in our culture. Because of their educational purpose, accurate and consistent messages, and commitment to preservation of objects in perpetuity, museums are among our society's most trusted institutions.

Your museum's educational purpose is expressed in the *mission statement*. The exhibit's *main messages* should be congruent with the museum's mission, and rooted in scholarship and community knowledge. Financial responsibility, reflected in a *target budget* for your exhibit makeover, is an important part of the museum's commitment to preservation.

The Mission: Be Clear about Your Purpose

An exhibit makeover is not the institutional equivalent of plastic surgery. Museums that stray too far from their origins may tend to overbuild and overspend. Instead, *Exhibit Makeovers* recommends a thoughtful, organic process that helps you build on your strengths, put your best foot forward, and plan for gradual change based on who you really are.

Start from your museum's mission statement. The mission statement summarizes why your museum exists and identifies the people you serve. It reflects your distinct identity and purpose. Write the mission statement boldly and beautifully on a large sheet of newsprint or poster board, and refer to it throughout your exhibit makeover process. The museum's mission will be a fixed star to guide you through your planning journey.

Do you sense that your mission statement may be outdated or incomplete? See appendix B for a step-by-step guide to examining and revising your mission statement.

Main Messages: What Do Visitors Take Home?

In defining the purpose of a museum exhibit, internationally known museum planner Barry Lord emphasizes two key qualities of an effective exhibit: *meaning* and *authenticity*.

"The purpose of a museum exhibition is to transform some aspect of the visitor's interests, attitudes, or values affectively, due to the visitor's discovery of some level of meaning in the objects on display— a discovery that is stimulated and sustained by the visitor's confidence in the perceived authenticity of those objects." ("The Purpose of Museum Exhibitions," in Lord and Lord, *The Manual of Museum Exhibitions*, p. 19.)

Whether your exhibit makeover begins with a single case, a gallery, or the whole museum, it's vital to decide on the big idea messages that you want all visitors to take home from their experience.

Take-home messages don't necessarily appear anywhere in your exhibits. They are the moral, the summing up, and the memory that visitors take home and apply to their own lives. Like your museum's mission statement, take-home messages will guide you as you develop the storyline, research the content, get feedback from potential visitors, create the exhibit design, and build and install the finished product.

Don't skip this step! If you don't choose your take-home messages, they will choose you. Exhibits without clear and conscious take-home messages run the risk of being confusing, frustrating, incomprehensible, or even insulting to visitors. Some might conclude, "This museum makes me feel stupid," or "History is boring," or "A five-year-old could make better art than this."

Visitors who arrive at such conclusions are unlikely to make a return trip to your museum. Even worse, they may be turned off to museums permanently.

BRAINSTORMING: WHY AND HOW

Brainstorming is a great way to capture everyone's creative ideas. In response to a question, people throw out ideas. There is no criticism or discussion during brainstorming. One person serves as facilitator:

- Capture ideas on a big newsprint pad, mounted on an easel so everyone can see.
- Make sure people speak one at a time, so each idea can be recorded.
- Give everyone a chance to speak.
- Ensure that no one dominates or criticizes.

Don't reinforce stereotypes of snooty, exclusive museums. Resolve to engage a genuine cross-section of your community, by interpreting a dynamic set of take-home messages.

Take as much time as you need to create your take-home messages. It's best to develop them deliberately, through brainstorming and discussion.

Examples of Take-Home Messages

Every artistic/intellectual creation (exhibit, novel, painting, film, album, performance, etc.) communicates a few big ideas to most audience members. For example:

- **The Story:** *Lord of the Rings* tells about a quest— a seemingly hopeless effort by a few outnumbered souls to save their world from destruction.
- **The Film:** Each of the three films in the *Lord of the Rings* trilogy honors the spirit of J.R.R. Tolkien's fantasy novels.
- **Personal Meaning:** If Frodo and Sam could do it, why can't I?

In a museum setting, take-home messages fall into three main categories:

- **The Story:** At the Lincoln Museum: Abraham Lincoln saved the American Experiment. At the National Steinbeck Center: Through his writings, John Steinbeck transformed the Salinas Valley into the Valley of the World. At the Columbia River Maritime Museum: The Columbia River is both a gateway and a barrier to the Pacific Northwest. Though jetties and dredging have stabilized the Bar, it can still be dangerous and even deadly.
- **The Museum:** At the Denver Botanical Garden: This is a botanical garden, not a public park. At the Confederated Tribes of Warm Springs: The Museum at Warm Springs is about the values and traditions of our community. At the Indiana Historical Society: The Indiana Historical Society is a fun place. I want to come back!
- **Personal Meaning:** At the Northwest Museum of Arts and Culture: People like me are welcome at this museum. At the Historic Belmont Firehouse: My safety is my responsibility.

Strive for an enthusiastic consensus about your take-home messages. Make them specific, yet noble and inspiring.

For each category, decide on the single most important big idea, for a total of three take-home messages. Record your take-home messages on Worksheet 1A.

Take-Home Messages for _____
Name of our museum

Visitors will leave with the following take-home messages in mind:

Message about the Stories Told Here	
Message about This Museum	
Message about Myself (the visitor)	

The Target Budget: What Is Our Price Range?

The chart in Worksheet 1B shows typical exhibit elements in different exhibit price ranges.

Circle the phrases and exhibit elements that best describe your museum. Use the worksheet as a diagnostic tool to determine (or reaffirm) what your target budget will be for this project: minimal cost, low cost, moderate cost, or high cost. If you opt for minimal cost, look for affordable ways to improve exhibit quality, such as in-kind donations of services and materials.

The Exhibit Makeover Crew has reaffirmed your mission, established a clear set of take-home messages, and determined your target budget for the project. You're ready to focus on a specific makeover project.

The rest of the book will guide you through this process. Part 1, Starting Small (chapters 2 and 3), is devoted to a single-case exhibit makeover. Part 2, Strengthening Skills (chapters 4, 5, 6, and 7) focuses on a gallery-level exhibit makeover. And finally part 3, Involve Your Community (chapters 8 and 9), expands the exhibit makeover process to encompass your entire small museum.

Exhibit Elements Checklist

Exhibit Elements	Minimal-Cost Exhibit ($0–$149/sq. ft.)	Low-Cost Exhibit ($150–$179/sq. ft.)	Moderate-Cost Exhibit ($180–$229/sq. ft.)	High-Cost Exhibit ($230+/sq. ft.)
Presentation media—text	Adequate text, but not too much Calligraphy labels or uniform font and size Visible title Theme and storyline	Vary typefaces and point sizes Use changeable bulletin boards Provide opportunities for visitor feedback	Use layers of information for visitors to discover	Use electronic displays Consider having text projected onto a wall or other surface
Presentation media—sound	N/A	N/A	Produce in-house as MP3 files For playback, use iPods, repeater chips	Have professionally produced Use a durable playback device
Presentation media—video	N/A	N/A	Produce in-house using iMovie and camcorder For playback, use computer and monitor	Have professionally produced Use durable playback device
Presentation media—interactives	Touchable opportunities	Include hands-on and touchable opportunities	Use liftboards, sliding panels, matching games	Include computer-based interactives
Presentation media—smells	Changeable samples (herbs, raw wool, scent bottles)	Use changeable samples (herbs, raw wool, scent bottles)	Use changeable samples (herbs, raw wool, scent bottles)	Employ automated release of synthetic odors
Furniture and décor	Used cases Cast-offs from retail stores	Panels Pedestals	Plexiglas cases Stage sets with inexpensive props Period rooms Art installations Changeable components	Dioramas Full-size replicas Environments Mannequins Media environments
Aesthetic and environmental elements	Color unity Use of fabric Sense of unity No clutter or overcrowding	Color (paint) Textures: fabric Layout (spacious or crowded) Social or solitary experience Random or directed access	Color (graphics) Textures: floor and wall materials Visitor comfort (benches, accessible design)	Color (photos) Lighting

STARTING SMALL

Plan a Single-Case Exhibit Makeover

IN THIS CHAPTER, THE EXHIBIT MAKEOVER CREW WILL first identify an existing single-case exhibit in need of improvement. Focused worksheets will then take you step-by-step through the makeover process. You'll try out new skills in team-building, exhibit planning, and exhibit design. You'll document your best ideas and key decisions in a series of record-keeping worksheets. Then in chapter 3, you'll summarize the elements of your exhibit, design and install your single-case exhibit, and share the results of your exhibit makeover with museum visitors.

ASSEMBLE YOUR MAKEOVER CREW

For a single-case exhibit, bring together three people who care about the museum and who are willing to try a fresh approach. Your Exhibit Makeover Crew might include (for instance) a board member, a staff member, and a volunteer. Recruit people for the planning team who enjoy working collaboratively.

As you work through the exhibit makeover process, allow for periods of brainstorming and "creative chaos" when anything goes. Find ways to make key decisions as a group, and commit to them. Aim for decision-making by consensus, including agreement on alternatives to be explored.

Ask for a volunteer to serve as your recorder. The recorder will capture and preserve the results of the group's work on each of the exhibit makeover exercises. Remember, you may photocopy any of the worksheets in this book, and feel free to modify them. Use the completed worksheets to build an exhibit makeover notebook, a record of your plans, decisions, and accomplishments.

Relax, enjoy each other's company, and have fun! This is meaningful work, but it needn't be stressful. Tune into your creative selves as you brainstorm ways to make an exhibit more appealing and interesting to your museum's visitors.

CHOOSE A SINGLE-CASE EXHIBIT FOR YOUR MAKEOVER

Some ideas for which exhibit to choose:

- The exhibit that visitors never seem to notice.

- A case that's too crowded or too sparse.
- Great artifacts, unsatisfactory images (or none), little or no interpretation.
- An exhibit that staff and volunteers have been complaining about for years.
- The oldest display in the museum.
- An exhibit near the front door that could create a better first impression.

THE "SO WHAT" OF YOUR EXHIBIT: THE STORYLINE

It's important to organize the exhibit around a storyline. The storyline expands on the take-home messages, encapsulating the core meaning of the exhibit in a succinct and compelling way. The storyline is the premise of the exhibit and answers the question: "So what? Why go to all the time and trouble to create this experience for visitors?"

Storylines are as varied as the subject matter of museums. For instance:

- The Lincoln Museum in Fort Wayne, Indiana, interprets the life and times of one of the most famous presidents. The main take-home message is that Lincoln saved the American Experiment. The exhibit storyline explains how in Lincoln's day, when the United States was less than 100 years old, many doubted whether this experiment in democracy would survive. Through his actions as commander in chief, Abraham Lincoln saved the Union from breaking up into three different countries: the industrial North, the slave-holding agrarian South, and the expanding West.
- The Panhandle Plains Historical Museum in Canyon, Texas, tells a regional story. To outsiders, the Panhandle seems a desolate and inhospitable place, yet people have lived there successfully for at least 12,000 years. How have they managed this? An exhibit titled *Experiments in Living* compares the ways in which people have addressed core life problems, from prehistory through the present day. (This approach was intended to challenge visitors' assumptions about the superiority of contemporary Panhandle cultures, by placing today's lifestyles on the same plane as earlier "experiments.")

- *Treasures from the Trunk: Quilts of the Oregon Trail*, a 1993 temporary exhibit, brought ten heritage quilts to the Douglas County Museum in Roseburg, Oregon. Each quilt was made or owned by a woman who journeyed across the Oregon Trail in the mid-1800s. Quotes and historical evidence powerfully conveyed the message that none of these women had wanted to leave their homes and families; it was their husbands' idea to undertake the perilous journey across the Plains.

CREATE IDEAS FOR YOUR STORYLINE

As you begin the makeover process, brainstorm ideas for your exhibit storyline. Aim for juicy ideas, with built-in drama and human interest. Remember, you are not writing this sermon with the choir in mind. The idea is to tell your story in a way that will engage and motivate people who are new to your museum—including some who have never before set foot in *any* museum. Worksheet 2A guides you through the storyline brainstorming process. Keep your responses to Worksheet 2A handy as you follow the steps in this chapter. As you move deeper into planning, the exhibit storyline will begin to take shape.

STORYLINE DEVELOPMENT

The next step for the Exhibit Makeover Crew is to inventory the content that's available for your exhibit: stories, information, objects, images, and more. Although you may feel that you already know this material inside out, don't skip this step. An important benefit of the makeover process is the opportunity to view familiar material with new eyes. Who knows what previously unknown treasures you may discover?

In that light, it's a good idea to open up your process, by asking guest experts to share their knowledge and perspectives. Invite them to your meetings, or deputize Exhibit Makeover Crew members to interview resource people in their homes or offices. Explain what you are doing; take careful notes. Don't quote these resource people in the exhibit without asking

their permission, and be sure to give them credit for their assistance.

Worksheet 2B will help you identify scholars, elders, community resource people, and other experts who may be willing to assist. Note that some research may be required to find the right people. And once you find them, you may need diplomatic skills to build trust and relationships before people will be willing to share.

Make sure to offer multiple perspectives on controversial topics; for example, an exhibit about a strike should offer first-person information from the perspectives of workers and managers.

An exhibit that interprets the history and experience of a particular group MUST be developed in consultation with members of that group. If that turns out not to be possible at this time, you will need to find another topic. (Please note: This is especially important in the case of American Indians, who are often presumed to have "vanished" or "died out" in a particular region. This is *never* the case. American Indian people can be found everywhere in the United States. They may be your next-door neighbors!)

GET YOUR STORIES STRAIGHT

Facts, concepts, themes, and values are the verbal raw material of exhibit content.

Facts: Less Is More

For most museum visitors, facts are most relevant when associated with objects and images. A visit to a museum is like a detective story: *What's that? Who made that? What's it for?* These and similar questions spring to mind when a visitor's curiosity is aroused.

Facts come in two main varieties. Some are self-evident: we can see that a particular mask is painted blue. Other facts might be termed "insider information." The person who made and used this mask could tell us that she decorated it with cobalt-based paint and wore it in a harvest ceremony. An anthropologist or other firsthand observer could also provide this information.

Some facts are more compelling than others. Children are fascinated by the fact that something as big as a dinosaur once lived on earth, and is no more. When someone you know goes to jail for cooking his employer's books, that's a disconcerting fact. As a general principle, if a fact is good gossip material or a conversation-starter, it will attract and hold visitors' attention.

The exhibit should include factual answers to frequently asked questions. Here's an example of a

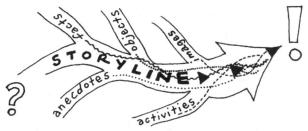

Figure 2.1. A varied collection of facts, objects, viewpoints, and interactive elements enriches the storyline for the visitor.

Storyline Ideas for _____
Name of exhibit

Main take-home message about content (from worksheet 1A):

If you were going to tell the story behind this take-home message in a sentence or two, how would you tell it? (Brainstorm ideas, pick the top two or three, and record them here.)

If someone asked "So what?" about this take-home message, how would you answer that question? (Brainstorm ideas, pick the top two or three, and record them here.)

wasted opportunity. Decades ago, one of your authors visited an exhibit called *Art of the Sepik River.* Several objects in the show were labeled "lime pipe," with no further explanation. The question "What the heck is a lime pipe, anyway?" was the main message visitors took away from that experience.

Use Worksheet 2C to develop the main facts your exhibit will convey.

Concepts: The Light Bulb Goes On

Concepts are ideas—organizing principles that shape how we see our world.

Who Knows the Stories?

Storyline Element	Which People Know the Most about This Aspect of the Story?

Main Facts

What are the juiciest, most compelling facts about our subject matter?

What are the two or three most important facts people need to know about our subject matter?

What are the most frequent questions people ask about our subject matter?

Do the facts listed above answer these frequently asked questions? If not, add relevant facts.

What stereotypes and misconceptions do people have about our subject matter?

Do the facts listed above correct these stereotypes and misconceptions? If not, add relevant facts.

Your take-home message is a Big Idea—an overarching concept that you want most visitors to understand and remember. You'll also frame your exhibit around other kinds of ideas. Here are some useful organizing concepts:

CATEGORY. If you have a fine collection that relates to your storyline—branding irons, 1920s dresses, butterfly specimens—consider including them in your exhibit. However, the fact that the Exhibit Makeover Crew finds a category of objects fascinating doesn't mean those objects will automatically appeal to visitors. Spend time as a group sharing how you first fell in love with branding irons, 1920s dresses, or butterflies. Then figure out ways to offer your visitors a similar opportunity.

An exhibit on African hats (*Crowning Achievements: African Arts of Dressing the Head*, High Museum of Art, 1997) displayed amazing hats from all over Africa in four-sided Plexiglas cases. For each hat, four illustrated labels explained who made the hat, how it was made, how it was used, and how it ended up in the museum's collection.

Visitors read each label completely, and looked carefully and repeatedly at each hat. Whoever organized this exhibit understood that people are insatiably curious, and capable of learning just about anything!

CHRONOLOGY. Does your storyline have a beginning, middle, and end? If so, you may decide to organize the content chronologically, along a timeline.

(Warning: Some people demand a timeline because they feel lost without it. Others find that timelines make their eyes glaze over.)

An alternative solution to the time problem is to contrast "then and now." What was the floor plan of a typical family home in 1600 and today? When did men wear beards and when did they shave them off? How did people in North America cook their food in pre-contact Native cultures, in the pre-industrial era, in the nineteenth century, and before the microwave oven?

ANALOGY. To help visitors understand a complex concept, use analogies to familiar processes.

An exhibit about adaptation invited visitors to compare different types of bird beaks to tools such as pliers, a hammer, and tongs. (This example from the University of Oregon Museum of Natural and Cultural History is no longer on display, but its memory remains fresh.)

OBSERVATION AND DEDUCTION. Visitors enjoy solving problems. Is there a special object in your collection that has a story behind it? Consider including that object in your exhibit, along with helpful hints (objects, images, quotes, and information) to help visitors discover what it means.

Figures 2.2a and 2.2b. A discovery object is a simple way to engage visitors as they combine what they have learned from the exhibit with their personal knowledge to investigate an unusual object or image.

An exhibit on Africa at the Field Museum of Natural History included a mysterious object: a piece of wood the size of a bowling ball, with dozens of nails pounded into it. Through label copy and photographs, visitors had the opportunity to learn that in this particular African culture, when two people had a dispute, they were brought together in front of the whole village to work it out. Finally they would agree on a compromise. Then each person pounded a nail into the piece of wood as a sign of his or her commitment to this agreement. What an "aha!" moment for visitors, to learn that such a nondescript object could carry so much social meaning—and that a community could resolve disputes in such a creative way.

COMPARISON AND CONTRAST. An object that seems familiar to the Exhibit Makeover Crew may be completely mysterious to many visitors. A child whose shoes are purchased at the mall may have trouble grasping the idea that people can make shoes by hand from natural materials. A pair of manufactured sneakers displayed next to woven sagebrush bark sandals helps visitors make the connection.

WATCHWORDS. English speakers say, "Two heads are better than one." Masai people say, "No head can hold all wisdom." In the United States, people say, "It's raining cats and dogs." Greek speakers say, "It's raining tables and chairs."

Look for proverbial expressions, song lyrics, poems, and other quotes that sum up familiar and unfamiliar ways of understanding the world. These intriguing sayings show why cultural diversity is essential. They also add meat and zest to your storyline.

THEMES. A theme is a concept that shows up repeatedly throughout an exhibit. Deeply embedded in the subject matter, a theme expresses the essence of a person, group, or situation. For example, the Museum at Warm Springs celebrates the traditions and values of the Confederated Tribes of Warm Springs, Oregon. The importance of elders is a core value, represented by words and images of tribal elders throughout the exhibit gallery.

Worksheet 2D will aid the Exhibit Makeover Crew in determining the key organizing concepts for your exhibit.

WORKSHEET 2D

Organizing Concepts

Brainstorm possible organizing concepts and themes for your exhibit. (You don't need to fill in all the blanks, but try to come up with at least five or six different concepts and themes.)

Category _____

Chronology _____

Analogy _____

Observation/deduction _____

Comparison/contrast _____

Watchwords _____

Themes _____

Circle the concepts and themes that seem most revealing and engaging to the Exhibit Makeover Crew.

Do they belong in a certain order? If so, number them.

You'll ... back to Worksheet 2D in chapter 3, when you create your content summary (Worksheet 3B).

Values and Perspectives: Who Will Tell the Stories?
People are insatiably curious about everything, especially important things—the whys and wherefores of history, natural history, art, and science. At the same time, each person brings a unique set of experiences and perspectives to your exhibit.

How can you make the most of your visitors' curiosity and knowledge? One way is to let them know that their questions and knowledge are valued, accepted, and encouraged in your museum.

A single viewpoint—especially in relation to a controversial issue—will quickly be perceived as a party line. Offer multiple perspectives, inviting visitors to consider two or more viewpoints and come to their own conclusions.

Use first-person voices, in the form of quotes, eyewitness accounts, and oral histories, to illustrate multiple perspectives.

The Lincoln Museum in Fort Wayne, Indiana, interprets attitudes toward slavery before the Civil War. The vehicle is a political cartoon from the mid-nineteenth century showing a crowd of people, each with something to say. Quotes from abolitionists and pro-slavery apologists cycle through the "speech bubbles," giving visitors a representative sample of public opinion. Nearby, first-person quotes by former slaves are illustrated with black and white line drawings in a picture book showing what slavery was like for children.

Worksheet 2E helps the Exhibit Makeover Crew get a handle on complex, controversial topics, and how to interpret them effectively from multiple viewpoints.

EXHIBIT BUILDING BLOCKS

Exhibits are organized around ideas, but they are made up of things. To imagine the look and feel of your exhibit, you'll need to take an inventory of relevant objects and images in your current displays and in the museum's collections.

Multiple Perspectives

First, review your storyline and identify topics that are rich, complex, and controversial.

For each topic, brainstorm key viewpoints that should be represented, so that visitors can get a full picture and make up their own minds.

For each viewpoint, research first-person sources such as quotes, eyewitness accounts, and oral histories.

Complex/Controversial Topic	Viewpoints	Sources
#1	• • •	• • •
#2	• • •	• • •
#3	• • •	• • •

The next two worksheets include checklists that will help you create an overview of these exhibit building blocks. Work with the checklists to make preliminary choices about what objects and images *must* be displayed.

Objects

Objects made by people are known as *artifacts* in museum lingo. A stagecoach, the *Mona Lisa*, and a book are all artifacts.

Natural objects are called *specimens*. A quartz crystal, a bird's nest, and a whale skeleton are all specimens.

Museums are among the most trusted institutions in the United States, according to recent polls. You owe it to your visitors to display authentic originals, unless you tell them otherwise. If you wanted to show them the Rosetta Stone (one of the major attractions of London's British Museum), you would have to purchase a *replica*. A replica is a detailed, authenticated copy of an original, and should be labeled as such. ("Replica of the Rosetta Stone. Cast from the original in the British Museum.")

Above all, a trustworthy museum does not knowingly display a *fake* or *forgery*—a copy that has been disguised to look like an original.

Suppose a large object figures prominently in your story: a locomotive, an elephant, or a fishing village. Even if you had the object in question, there will prob-ably not be room for it in your single-case exhibit. (It might not even fit into any of your exhibit galleries!) One solution is to make or buy a *model*. Models are built to scale and include a wealth of instructive detail.

At the Royal British Columbia Museum in Victoria, Canada, a scale model of a Native fishing village takes up an entire gallery. Carved and constructed in minute detail, the model was years in the making. For visitors, it is the next best thing to traveling back in time to an actual village.

Another solution is to show the locomotive, elephant, or fishing village in stage set or graphic form, along with *props* that add dimensionality and visual interest.

When Abraham Lincoln was a young man, he took a load of freight down the Mississippi River on a flatboat. This was his first encounter with slaves and their masters. At the Lincoln Museum, visitors look up to see Lincoln (a mannequin) pulling on the flatboat's oar. Props such as barrels, crates, and a full-size figure of a pig create the impression of a load of goods headed for market.

Worksheet 2F will help the Exhibit Makeover Crew inventory objects for display and determine which objects *must* be displayed.

Images

Exhibit images are reproductions of historic or contemporary photographs, drawings, maps, documents, and other two-dimensional originals.

Why reproductions?

- Most originals are too light-sensitive to be displayed for more than a few weeks or even days without damage.
- Reproductions enable you to enlarge and crop images to make them more understandable, interesting, and attractive.

Worksheet 2G guides the Exhibit Makeover Crew as you identify possible images to be included in the exhibit and decide which images *must* be displayed.

With your record-keeping worksheets at hand, move on to chapter 3. You'll find step-by-step instructions for designing, producing, and installing your single-case exhibit makeover.

Objects

List all objects related to your storyline. Then select the most important objects that the Exhibit Makeover Crew agrees *must* be displayed, within the limits of your single-case exhibit.

For objects in your collection, note information (such as an accession number or other identifier) that will help you locate the object. A photo of each object with measurements (height, width, and depth) will be essential to plan the exhibit layout. A digital camera makes it easy to record and store information. If you're working with a film camera, stick a label on each print, and record identification information and measurements on it.

Finally, make a note of any must-display objects that aren't in your collection and should be acquired.

Type of Object	Description	Must Display	Collection ID #	To Be Acquired
Artifacts				
Specimens				
Replicas				
Models, props				

Images

List key images related to your storyline. Then select the most important images that must be displayed.

For images in your collection, note catalog numbers and other identifiers that will help you locate the image. (Be sure to copy information from the back of the photo, too.) If possible, scan or photocopy the images.

Finally, make a note of must-display images that aren't in your collection and should be acquired.

Type of Object	Description	Must Display	Collection ID #	To Be Acquired
Photographs				
Drawings				
Maps				
Documents				

Design and Install Your Single-Case Exhibit Makeover

IMAGINE THE "LOOK AND FEEL" OF YOUR EXHIBIT

TO IMAGINE WHAT YOUR EXHIBIT WILL LOOK LIKE, AND how visitors will experience the space, try some thought experiments. These warm-up exercises will get the Exhibit Makeover Crew thinking creatively.

Imagine must-display objects and images as actors in a play. What kind of stage set will help visitors get into the mood and spirit of the story they will act out?

- Hosts of a party. What's the theme of this party? How will you furnish the room so that visitors will feel comfortable and at home? What would make the party fun for them?
- Part of a story that is set in a particular time and place. How can you use colors, textures, furniture, materials, graphic and typography styles, sound and light, and other elements to transport people to another era or a different part of the world?
- Reflections of human experience and emotion. How could exhibit elements express the essential emotions of your story, such as joy, fear, sadness, or courage? What props and décor could proclaim what this exhibit is all about—family, work, sport, overcoming challenges, or other dimensions of life?

Brainstorm, discuss, and kick ideas around. Record your best ideas in Worksheet 3A.

Now with Worksheet 3B, analyze the results, and make necessary cuts to tighten the exhibit presentation. Each must-display item should correspond to an organizing concept or main fact, and vice versa.

Circle any concept or fact without a corresponding object or image. Decide whether to add one or more objects or images, or drop those concepts and facts.

Do the remaining objects, images, concepts, and facts convey the most important take-home messages? If not, decide whether to drop one or two messages or add to the objects, images, concepts, and facts.

Next, go back to Worksheet 1B, the Exhibit Elements Checklist, to identify potential hands-on, touchable, interactive, and media-based exhibit elements that line up with your plans, the size of your exhibit case, and your budget! List them in Worksheet 3C.

The final step in planning your single-case exhibit makeover is to summarize your choices about exhibit content and visitor experiences in a preliminary exhibit outline, Worksheet 3D.

DESIGNING YOUR SINGLE-CASE EXHIBIT

A well-designed exhibit—whether large or small—has a distinct visual style that communicates key messages about the content to viewers from across the room. This is usually accomplished through the

Look-and-Feel Ideas

List preliminary ideas about look and feel that appeal to everyone on the Exhibit Makeover Crew.

Content Summary

Using worksheets you've already completed, summarize your choices so far. Line up objects/images with their corresponding facts and concepts.

Take-Home Messages: from Worksheet 1A	Organizing Concepts: from Worksheet 2D	Main Facts: from Worksheet 2C	Must-Display Objects and Images: from Worksheets 2F and 2G
•	•	•	•
•	•	•	•
•	•	•	•
	•	•	•
	•	•	•
	•	•	•
	•	•	•
	•	•	•
	•	•	•
	•	•	•
	•	•	•
	•	•	•
	•	•	•
	•		

Interactive Opportunities

List interactive opportunities appropriate to your content, look-and-feel ideas, and price range.

Preliminary Exhibit Outline

Draw on previously completed worksheets to rough out a preliminary exhibit outline.

Big Idea (most important take-home message from Worksheet 1A):

Working exhibit title (based on Big Idea):

Concept:		
Facts:		
Images:	Objects:	Interactives:

Concept:		
Facts:		
Images:	Objects:	Interactives:

Concept:		
Facts:		
Images:	Objects:	Interactives:

use of one or several design "tricks" that you can use in your display.

Scale

If you have many small or similarly sized objects to work with, consider enlarging one element to draw people in (see "Filling the Holes" section of chapter 6). This could be accomplished by photographing or scanning an object or image and enlarging it to use as a backdrop for a section of your display.

Color

Gather your objects on a table with a neutral— white or off-white—background (cover a table with clean butcher paper, available at craft stores on rolls, or a simple white tablecloth). Ideally, your table would be about the same size as your case—if not, consider approaching this exercise in sections. Study the colors of the objects and discuss what might be complementary or contrasting color options. Perhaps a darker or lighter neutral color is needed to allow the natural variety of colors and forms to be seen clearly. Or perhaps the color range is a little dull, so a bright or dramatic color is need to liven up the objects.

Craft and art supply stores sell sheets of drawing papers in 18 × 24 inch sheets in a large variety of colors. Once you have some colors in mind, purchase a few of these to try out colors as part of your display in the backdrop, headlines, or text areas.

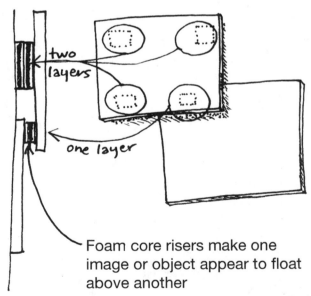

Foam core risers make one image or object appear to float above another

Figure 3.1. Small pieces of foam core, cut and attached with double-stick tape, can be used to add the illusion of depth to overlapping objects or images on an otherwise flat background.

Active Dimensions

Often our first impulse is to think of our display cases as flat or one-dimensional spaces with elements arranged horizontally in line with the edges of the display unit. This arrangement tends to lead to a static, or inactive, layout. In addition to scale and color, simply taking one element of your display, such as a headline or object, and "breaking out" of the flat, right-angled grid adds activity and interest to the case.

Some examples might be:

- An object or text panel that is suspended away from the back panel of the case appears to step forward toward the visitor.
- Objects or text panels that overlap instantly add a sense of depth to the case.
- Objects can appear to float in a case either by being suspended with monofilament line or being set out from a backdrop on wire.
- A flat object can be pushed out from the back of a case with layers of foam core cut somewhat smaller than the object's dimensions.

Dynamic Angles and Groupings

While you have your objects out on the table, take time to explore some playful and unusual arrangements of the pieces. A good exercise would be to start with them in the most static, even arrangement you can think of—as if each one were in a little compartment by itself with no sense of organization other than being placed neatly on a set of evenly spaced shelves.

Now consider your organizing concepts from Worksheet 2D. Which of these concepts can be represented by the placement of your objects on the table? Which makes the most sense with the story that you are telling? Some examples might be:

- **A timeline:** The objects tell the story in a chronological order.
- **Context:** Some objects may belong together because they were all owned by the same family or were part of the same historical event.
- **Compare and contrast:** A dozen examples of different objects that are related by function will be interesting to see side by side.

Which of these arrangements is the most visually pleasing, or tells the story best? Take digital images of groupings that you particularly like, so that you can easily recreate them in your final case.

This is also a good opportunity to think "outside the case" if there is a blank wall that adjoins your display area. Why not hang a headline, graphic panel, or model, or create an oversized cut-out object (see "Filling the Holes" in chapter 6) that relates to your topic and grabs attention from across the room?

Try to group your text elements as much as possible without sacrificing clarity. In a small case, little white tags next to each object in a group can be quite distracting. Consider a panel with a general statement about the group, and an outline diagram with each object lettered to match its description (figures 3.2a and 3.2b). Create one panel for each group or section of your case, so that visitors can find all the information about that topic or grouping in one location.

A STEP-BY-STEP BLUEPRINT

Take accurate measurements of your case and create a scale drawing of your space. If you are using a wall area near the case, be sure to include this area as well. Make this drawing as large as possible and practical for the team to share—you'll find it easier to visualize things when they are closer to the actual scale of your final display.

1. Use paper cutouts, also to scale, to approximate objects, images, text panels, and groupings that will form the display. Work from the object measurements from Worksheet 2F and your images from the grouping exercise above so that your shapes reflect the real dimensions of your elements. If you are using large sections of color, use colored paper to approximate these areas as well.
2. Arrange and rearrange these pieces until you feel that you have found a balance of objects, images, and text that tells your story and shows off the objects and images well. If things seem too crowded, consider editing out part of the story (save it for another time). If things seem a little sparse, consider enlarging some of your images or creating a backdrop that complements the period or message of the display.
3. When you find the perfect balance, tape your papers down, and use this as a master guide to prepare for your installation.

ASSEMBLING THE PIECES

The graphic panels and backgrounds are often the first sections of an exhibit installation. Keep your graphics simple by limiting yourself to one font or typeface with a minimum of bold and italic variations. White type on a dark or black background is difficult to light

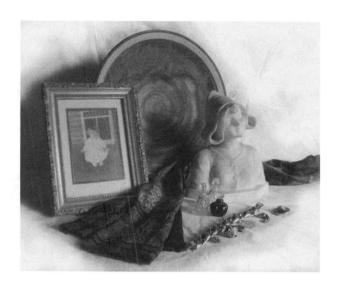

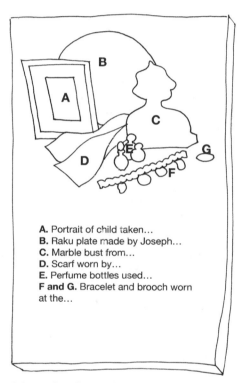

A. Portrait of child taken…
B. Raku plate made by Joseph…
C. Marble bust from…
D. Scarf worn by…
E. Perfume bottles used…
F and G. Bracelet and brooch worn at the…

Figures 3.2a and 3.2b. Rather than placing a small label next to each item in a grouping, create a key with outlines and letters to identify multiple objects with a single label.

well and read, so avoid that combination. Mount your graphic panels on acid-free board and trim them neatly (see chapter 7 for more on exhibit materials).

Some of your objects or images may need to be propped up or held in place to show well, or may need protection if a case can be bumped or shaken. Consider each object before you begin, and consult with a curator or conservator in your region for ideas about

archival-quality materials to hold these pieces in place. Various kinds of tape that you might use at home (including duct tape and Scotch tape) are not compatible with museum displays.

Take time to think through and jot down a schedule with a list of installation tasks. Note which of the parts can be prepared in advance (e.g., text panels, mounting and framing), as well as what needs to be done on site (e.g., painting, hanging objects). Are there tasks that require two or more sets of hands to complete safely? Do you have any special tools or hangers that you will need?

If space and security allow, assemble all of your elements in a staging area a day or so before you install everything. Review the installation plans with your team to be sure that there aren't any holes in your schedule, equipment, or materials. Installing a new exhibit is stressful enough without three trips to the hardware store!

COMMONSENSE INSTALLATION

If this is your first installation, allow lots of extra time. Don't install the day before the opening—install three days before.

Install when the museum is closed if possible. If not, block the space around the case so that visitors are not in the area. This will protect your objects from accidents and your visitors from tools, dropcloths, and ladders.

Be thoughtful about lighting. Direct sun and bright incandescent lights can be harmful to many materials and possibly to the inks in your graphic panels. A lower level of fluorescent light or indirect, filtered natural light outside of a case will be much safer.

Wear gloves (white cotton) when handling delicate objects. This will also protect your display panels from fingerprints.

Secure everything carefully. Don't worry if a pin or wire shows—it is more important that artifacts are safe from things that go bump in the night.

Clean the inside of the case with nontoxic glass cleaner as you work through sections—it may be impossible to reach a section of glass after elements are arranged. Clean the outside of the case thoroughly once you are finished. Clean every day for dust and fingerprints once the exhibit is open.

Congratulations! You've completed your first exhibit makeover. You've exercised your team-building, exhibit development, and record-keeping skills to transform a single-case exhibit. The best news is that when you're ready to take on another exhibit makeover, of an exhibit gallery or even your whole museum, these skills, processes, and worksheets will be directly applicable. In its physical form, an exhibit gallery is a collection of cases and related interpretive elements, planned and designed using the same methods you've used successfully to do your first, single-case exhibit makeover. Remember: the most important goal of any exhibit makeover—single-case, gallery-level, or museum-wide—is to offer engaging and meaningful experiences to your visitors.

VISITOR FEEDBACK

When a baby is born after many months of preparation, the journey of parenthood begins. As "parents" of a new exhibit, the Exhibit Makeover Crew will be curious to learn what visitors think of it. Discreetly watch how visitors react to the exhibit. Do they take time to look, listen, interact, and read? Are they eager to share their thoughts with friends and family? Do some visitors seem puzzled, or even upset at times? Do some people ignore the new exhibit, or miss it completely?

Take notes (or make mental notes) about any problems you see. Without interrupting the flow of the visit, ask visitors if they have any questions or comments about the exhibit. Listen with an open mind; don't correct visitors, but try to understand and record their thoughts. Seek to identify any aspects of the exhibit that aren't working well for visitors.

Show visitors that you welcome their comments. Place a comment book (loose-leaf notebook or ruled notepad) and pen on a table in a prominent location, with a chair that invites people to sit down and tell you what they think. In a brief, friendly label, ask visitors to share their thoughts and feelings about the exhibit. What questions do they have? What suggestions do they have for improving the exhibit? You can't please everybody; but it's well worth it to address the problems and suggestions that are most frequently mentioned by visitors. Your exhibit will improve as a result.

STRENGTHENING SKILLS: AN EXHIBIT GALLERY MAKEOVER

Working as a Creative Team

CHAPTERS 4–7 TAKE YOU STEP-BY-STEP THROUGH AN exhibit gallery makeover. Exercises and worksheets strengthen skills in team-building, exhibit planning and design, and documentation/record-keeping. The end result is a revitalized exhibit gallery that can serve as a model for other galleries and even for the museum as a whole.

In this chapter, the Exhibit Makeover Crew will expand its membership in preparation for an exhibit gallery makeover, then practice working as a creative team by participating in two warm-up exercises.

The "insider" Exhibit Makeover Crew that successfully improved a single-case exhibit will recruit new members for a larger, more diverse Exhibit Makeover Crew. Look for people who care about the museum, are willing to try a fresh approach, and enjoy being part of a team. Your Exhibit Makeover Crew of 10–12 people may include volunteers, staff members, board members, museum members, and other stakeholders.

Depending on the Crew's preferences, you might choose one person to facilitate, you might take turns chairing the group, or you might work without a facilitator. Designate a recorder to capture and preserve the results of the group's work on each of the exhibit makeover exercises. Build an exhibit makeover notebook, where you record your plans, decisions, and accomplishments.

As you work through the process, make key decisions as a group, write them down, and stick with them. Aim for decision-making by consensus, including agreement on alternatives to be explored. If you get stuck, consider recruiting a skilled facilitator from outside the group to help you move forward.

CREATIVE WARM-UPS

Before you plunge into the actual work of designing, building, and installing your exhibit, set aside some time for building your creativity as a team.

These warm-up exercises give the Exhibit Makeover Crew the opportunity to experiment with collaborative planning. By freeing up your minds and

letting the creative juices flow, you may come up with some wonderful exhibit ideas!

WARM-UP EXERCISE #1: POCKET ARCHAEOLOGY
Each person from the Exhibit Makeover Crew chooses an everyday object from a pocket or purse and puts it with others' objects on a tabletop.

Now, choose a partner to work with.

You are archaeologists in the year 3000. These assembled objects are the findings of your latest dig. You have dated the site to about 2000, a little-known period in human history. Using only these objects, develop an idea for a small exhibit that interprets this previously unknown culture to museum visitors.

Allow 5–10 minutes, then share your concepts with the whole Exhibit Makeover Crew. How many different approaches did you come up with? (Remember this time-honored principle of exhibit design: "There's more than one way to skin a cat.")

WARM-UP EXERCISE #2:
TELLING MEANINGFUL STORIES
This exercise gets everyone working together to interpret historic artifacts and images in meaningful and engaging ways. The Exhibit Makeover Crew comes up

with creative exhibit ideas that put family stories and heirloom artifacts into a broader context, accessible and interesting to most visitors. This is the core challenge of most exhibit planning: how to make specific facts, images, and objects interesting and relevant to a wide range of people.

Ask each member of the Exhibit Makeover Crew to bring an object or image that is special to him or her. (Ask people not to share personal information about their special item until later on in the exercise.)

Arrange the objects on a table where everyone can study them. Establish "no handling" rules or provide white gloves. Make copies of photographs for everyone.

As a team, focus on one object or photograph at a time. Use your observational and brainstorming skills to share viewpoints on the meaning of these heirlooms. What clues does each photograph offer about particular people and families, and the historic context of their lives? What can the objects tell you about how, where, and when they might have been made? How does each object and image relate to regional, national, or global events and issues?

Following the general discussion of each item, invite the person who brought the item to share the inside story of the artifact or image. What makes a particular object special to the person who brought it to the meeting?

Using the information gleaned so far, rough out an outline for a gallery-size exhibit built around this set of objects and images. For an hour or two, work as a group to brainstorm an approach to the exhibit that would be engaging and rewarding for people of all ages and backgrounds.

At a minimum, your outline will include:

- Take-home messages.
- Storyline summary.
- Organizing concepts.
- Preliminary ideas about the look and feel of the exhibit.

If you want to take another step, add these components to the outline:

- A complex or controversial topic to be explored.
- A hands-on interactive opportunity.
- A media-based component.
- An exhibit title.

Record the results in Worksheet 4A.

When you've finished, discuss the experience of working together as an Exhibit Makeover Crew. What was most rewarding and fun about the exercise? What worked well? Discuss any obstacles or difficulties. Brainstorm ideas for improving the group's interaction.

In chapter 5, the Exhibit Makeover Crew will plan an exhibit gallery makeover, drawing on and strengthening skills that helped the smaller group do a single-case exhibit makeover. As you work together, keep the lines of communication open. And keep talking about creativity, collaboration, and group process!

Telling Meaningful Stories

Exhibit title	
Take-home messages	• • • • • •
Storyline summary	
Organizing concepts	• • • • • •
Complex/controversial topic	
Hands-on interactive experience	
Media-based component	
Look and feel of the exhibit	

Plan an Exhibit Gallery Makeover

IN THIS CHAPTER, THE EXPANDED EXHIBIT MAKEOVER Crew will identify an existing exhibit gallery in need of improvement. You'll revisit the worksheets in chapters 1–3, but this time, you'll be planning for a more complex visitor experience in a larger space. The process will likely take more time, and the results will be more extensive.

With the preliminary exhibit outline in hand, you'll begin the design process. Information and worksheets introduce the Exhibit Makeover Crew to the elements of gallery-level exhibit design. You'll share ideas and develop consensus about visual vocabulary, visitor flow, and exhibit layout. You'll begin measuring and documenting the objects and images to be incorporated into the design. New tools like the bubble diagram, floor plan, and planning matrix help the Exhibit Makeover Crew articulate design ideas and manage the project.

CHOOSE AN EXHIBIT GALLERY FOR YOUR MAKEOVER

Some ideas:

- A gallery that attracts few visitors.
- A gallery that feels crowded, confusing, and unfocused.
- A gallery with great artifacts or images but little or no interpretation.
- A gallery that staff and volunteers have been complaining about for years.
- The oldest gallery in the museum.
- A gallery near the front door that could create a better first impression.

DEVELOP THE EXHIBIT CONTENT

First, write the museum's mission on a large sheet of newsprint or poster board, and refer to it throughout your exhibit gallery makeover. Everything you do should support and advance the mission.

Photocopy all the worksheets from chapters 1–3. The Exhibit Makeover Crew will use them to develop content and concepts for the exhibit gallery makeover.

Keep a record of your plans, decisions, and accomplishments in the exhibit makeover notebook.

- Worksheet 1A—Take-home messages: What are the main messages to be conveyed to visitors in this exhibit gallery?
- Worksheet 1B—Exhibit elements checklist: What is your target budget for this project?
- Worksheet 2A—Storyline ideas: What is the premise of your exhibit gallery, the core meaning that answers the question "So what? Why go to all the time and trouble to create this experience for visitors?"
- Worksheet 2B—Who knows the stories? Who are the people in your community who know the most about the subject matter of your exhibit gallery?
- Worksheet 2C—Main facts: What are the compelling, important facts to be conveyed? What frequently asked questions should we answer? What stereotypes and misconceptions should we try to correct?
- Worksheet 2D—Organizing concepts: What are the ideas that will organize exhibit content into "galleries of thought"?
- Worksheet 2E—Multiple perspectives: What topics in your exhibit are rich, complex, and controversial? How will you represent differing viewpoints on these issues?
- Worksheet 2F—Objects: What objects are available, and which ones must be displayed?
- Worksheet 2G—Images: What images are available, and which ones must be displayed?
- Worksheet 3A—Look-and-feel ideas: What preliminary ideas about the exhibit gallery's look and feel appeal to everyone on the Exhibit Makeover Crew?
- Worksheet 3B—Content summary: Do your take-home messages, organizing concepts, main facts, and must-display objects and images line up, and do they reinforce one another?
- Worksheet 3C—Interactive opportunities: What affordable media and hands-on experiences will make the exhibit more fun, understandable, and meaningful for visitors?

The final step in planning your gallery-level exhibit makeover is to summarize your choices about exhibit

content and visitor experiences in a preliminary exhibit gallery outline in Worksheet 5A.

ASK FOR FEEDBACK

Before you begin the exhibit design phase, find out what visitors like—and don't like—about the exhibit gallery in its present state. Invite randomly selected visitors to walk through the gallery with you. To choose visitors randomly for your informal survey, count people as they walk through the door (or cross an imaginary line) into the gallery. Ask the eighth person (or third, or tenth) to participate. If he or she declines, say a polite thank you, and start counting again.

Explain to visitors who agree to participate that a museum group is working on a makeover of the gallery. If they were part of the Makeover Crew, what would they want to keep, eliminate, and add? Try to find out the reasons for their opinions. Write down what visitors say, in their own words. Discuss your findings with the Exhibit Makeover Crew, and adjust the preliminary gallery outline as you think appropriate.

You can also ask nonvisitors for feedback. Set up a table at a flea market, county fair, or other gathering place. Offer free passes to your museum in exchange for a brief interview. Select potential interviewees randomly, as described above. Ask them what they know about your exhibit topic—and what they would like to know. Write down their suggestions verbatim—or ask them to fill out a questionnaire.

IMAGINING YOUR EXHIBIT GALLERY DESIGN

To copy reality can be a good thing, but to invent it is better, much better.

—Giuseppe Verdi

An engaging exhibit awakens visitors' senses and focuses learning through a combination of drama and reality. While many of the elements are visual—lighting, color, scale, and juxtaposition—don't forget that touch, smells, and sounds carry powerful messages and trigger memory and learning in our brains.

VISUAL VOCABULARY

As you begin the design phase of your exhibit—whether it is a simple case or a gallery with lots of floor space—it is important for you and your group to develop a visual vocabulary for sharing your ideas. Just as it is difficult to stare down a blank piece of paper when trying to come up with an idea for a written message, it is equally difficult for most people to walk through an empty room and visualize elements to fill it and make it exciting. To help you avoid this blank canvas syndrome, it will be helpful if you and everyone on your Exhibit Makeover Crew become both visual researchers and collectors of found objects.

A combination of systematic and randomly collected visual information will provide you with a rich palette for discussion and inspiration.

Although collecting more items may seem challenging if you already feel you have too much material for your space, at this point you should move beyond the museum (or wherever your usual context is for this project) and search for more. The key to creativity is to search for things that really inspire you—and will in turn inspire your audience.

Remember the juicy gossip or fun fact that inspired your words in the storytelling section of this project? Now you are challenged to find visuals or other sensory pieces that are equally intriguing: a piece of fabric with a wonderful color or texture . . . an opening credit from a movie that made you laugh out loud with its freshness . . . a dramatic image projected on a backdrop that you saw at a concert or play . . .

Think about ideas or visuals from the past that have stayed with you. Approach your day-to-day errands with a fresh eye. A store display may hold an intriguing collection of objects, colors, and textures. A CD cover may capture a mood that is central to the history or culture of your collection.

Of course, it is not cheating to go in search of these in a more methodical way, by looking at books and magazines on design, theater, or interiors. And you'll probably want to visit hardware, fabric, and craft stores to collect ideas for color, texture, lighting, and special effects that might fit well with your project. Take a camera with you to capture ideas.

Make your deadline a meeting opportunity where your team can share findings. In preparation for this meeting, each member should evaluate objects and visuals, and sort them into groups. This grouping process allows each person to find commonalities and imagine connections from disparate sources. See figure 5.1 for what some of these groupings might look like.

After each member of the team has informally presented his or her favorite pieces to the rest of the group, arrange them around the room. Perhaps you will find the collected inspirations share similar traits or complement each other. Some may jump out as appropriate for certain message areas of your exhibit.

Preliminary Exhibit Gallery Outline

Draw on previously completed worksheets to rough out a preliminary exhibit gallery outline.

Big Idea (most important take-home message from Worksheet 1A):

Working exhibit title (based on Big Idea):

Concept:		
Facts:		
Images:	Objects:	Interactives:
Concept:		
Facts:		
Images:	Objects:	Interactives:
Concept:		
Facts:		
Images:	Objects:	Interactives:

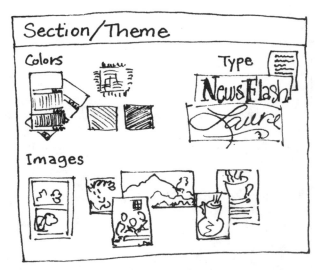

Figure 5.2. *Organize the inspiration pieces from various contributors in a way that is logical and helpful to your team, and refer back to them as you develop your visual style.*

Figure 5.1. *Materials collected for inspiration may include samples of typefaces, colors, textures, and styles that relate visually to your exhibit's themes.*

Revisit Worksheet 3A, Look-and-Feel Ideas. Are there styles, ideas, or inspirations that fit? Are there new ideas that are newer or fresher? Are there surprises that add a spark to the conversation? How could these add spark to your space (in large or small ways)?

It is likely that there will be some clear winners and losers in this exercise. What does this tell you about your audiences? While you can't please everyone, you can make choices that combine the facts and objects with a creative flair. At this point, one or two members of the team should assemble idea boards that will provide reference for visual styles of the elements. This could be an assemblage on a piece of matte board or foam core held together with glue or tape, or a bulletin board that will not be disturbed.

Depending on the size of your exhibit, you may end up with several boards, one for each content area or message, or simply one set of colors, textures, and ideas that you will use to tie everything together. This all may change and evolve as you work, but with the swatches, samples, photos, and typography handy, you'll be able to communicate more clearly with each other.

WHERE WILL EVERYTHING GO?

Before you focus on your objects—measuring each element and moving things around—take time to explore options in a series of quick and easy bubble diagrams. Bubble diagrams are a series of rough circles or squares that illustrate the various content areas of your exhibit (from Worksheet 5A). A large bubble may contain smaller bubbles to define an interactive section or a specific large object, but the bubble diagram's primary use is to provide overviews of dynamic possibilities or "galleries of thought"—the ideas that will become the organizing concepts of the exhibit.

If your Exhibit Makeover Crew includes a visual artist, he or she may be able to create thumbnails. These are small sketches that capture and explore creative ideas in a very rough form. While not essential, thumbnails can be a very helpful planning aid.

We are indebted to Craig Kerger of Formations Inc. for the notion of "galleries of thought" within the exhibit. These are the concepts that organize the exhibit into clusters of meaning. A well-designed exhibit is put together in a way that is recognizable to the people who know about the topic. They think, "This exhibit makes sense." And the well-designed exhibit is also accessible and understandable to nonspecialists, who begin to get a picture of what is unique and special about this topic.

With your galleries in mind, create a series of bubble diagrams within a proportionate outline of your available space (okay, so there is a little measuring at this point). Make sure to include any immovable objects clearly in your rough floor plan (existing walls,

cases, or other elements that you may be unable to alter due to structural or budget considerations). This exercise allows your team to share ideas about the flow and pacing of the floor plan or cases and visualize how your story will unfold.

See figures 5.3a and 5.3b for examples of bubble diagrams.

STREAKERS, STROLLERS, AND STUDIERS

As you probably already know, not everyone who comes to your museum or exhibit space will be equally captivated by your subject. Exhibit designers use the terms "streakers," "strollers," and "studiers" to describe three general types of museum visitors.

Some will be there only because Aunt Jane suggested your location as something to do while visiting your town, or the kids insisted on seeing the anime display they'd heard about, or admission was included in the price of their bus tour. These folks are what comics call a tough crowd; to museum professionals they are streakers. They read titles and headlines and might look at a few big pieces. Much of your hard work may be lost on them, but if you are clever enough, you may capture their attention and slow them down.

The next level of visitor is the stroller. Not a small child on wheels, but someone who has a moderate interest in the topic, region, collection, or (fill in the blank) that is the focus of your exhibit. A stroller is the equivalent of the person who picks up a magazine in the doctor's office because of moderate interest in the topic and flips through the pages, looking at the photos, headlines, and a few captions. Strollers pick up a few tidbits the first time they see the exhibit, and they may plan to come again to learn more and share.

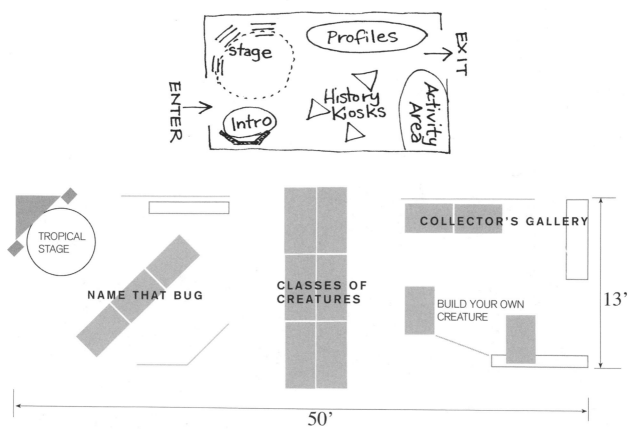

Figures 5.3a and 5.3b. *The first bubble diagrams should be done quickly by hand to record ideas and options while brainstorming. A more finished bubble diagram may be created with a computer or drawn carefully for presentation to others.*

Finally, the museum visitor who will absorb every detail of your work is the studier. This person may know and care a lot about your topic. Studiers will want to read *everything* during their first visit to the exhibit. They are also likely to point out any errors they may find and discuss the subtleties of the topic with museum staff and volunteers. This is often the target audience that you have in mind as an exhibit is created, but in reality these folks are a very small percentage of your visitors.

A truly balanced exhibit plan has something for each of these groups, and a really exceptional exhibit slows the streakers down to strollers and the strollers down to studiers. And when you consider the variety of age groups and abilities that may be present, you will need to make room for a variety of learning styles and interests in your plan. (If you want, skip ahead to chapter 8 and make use of Worksheet 8E, Accessibility Checklist.)

MAPPING YOUR DESIGN

Now is the time to start developing the various levels of your message on a more detailed floor plan or schematic drawing—we'll call it a map. Using measurements of the "must display" objects and images (although image size can change, we'll get to that later), the map allows you to detail the distribution of elements you'll bring together in the space.

Look at each of your objects and take accurate three-dimensional measurements. You'll also want to note the following:

- Are there conservation issues (sensitivity to light, humidity, dust)?
- Is this object touchable?
- Is security an issue for this object?
- What are the best possible options for mounting or presentation? (The answer to this question depends on the factors above combined with your budget, skills, and materials that you might have on hand).

Get clear about these factors now. They will affect your plans, budget, and schedule, along with your desire to make an aesthetically pleasing display.

An organizing tip: if you have many similar objects, get in the habit of using catalog or accession numbers (if you use them). Or assign a combination number and letter code to each object. Find a system that makes sense for your collection—it will help keep records and communications clear! See Worksheet 5B for one organizing system.

At this point, the Exhibit Makeover Crew will find it very helpful to create a fairly large-scale drawing of the space you plan to use—walls, cases, floor plans, or all of the above—and create paper pieces cut to scale for each major object (see a sample of a case display in figure 5.4). This could also be accomplished on a computer in a page layout program, but when working in a team, the low-tech cutouts are often more spontaneous and user-friendly. This tool allows you to play with floor plans or layouts based on real numbers, not vague spatial ideas. Low-tack, double-stick tape holds cutouts in place and allows you to reposition and experiment.

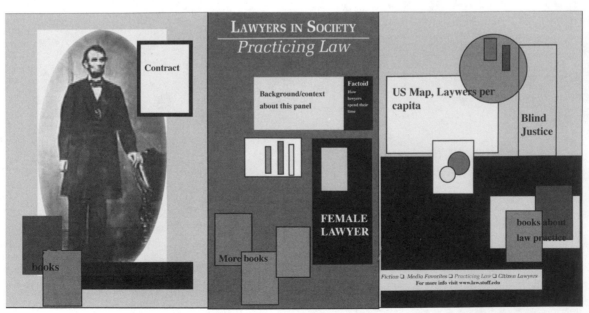

Figure 5.4. Paper or digital shapes drawn to scale can be moved around to visualize the fit of the objects, images, and text panels in the space.

Object Specifications

Object Name or ID Number	Dimensions: Height, Width, Depth	Conservation Needs	Security	Mounting

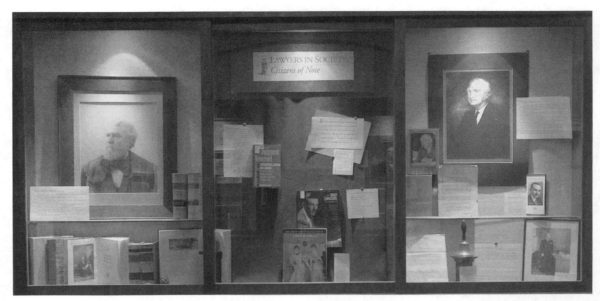

Figure 5.5. Photo of the case developed from the layout on page 36, showing how the layout was adjusted to accommodate the final objects and text panels while maintaining the agreed-upon style of the case.

While arranging these scale objects, you may see some patterns or challenges emerge. Consider the following as you view your map:

- Are your objects appropriately distributed throughout your space?
- Is there a variety of sizes and types of objects in each content section with supporting text?
- What will visitors see first when they enter an area?
- Is this experience dramatic enough to stop streakers in their tracks?

- Where do the interactives fit in?
- Is there too much or too little to fill the area?
- What should be cut or added to make the message more effective?
- How accessible is your space?

An important consideration is the *visual center*. When hanging objects, don't assume that the visitor's eye level matches your own (e.g., 63 inches for a 5-foot 10-inch person). The result may be far too high for anyone who is petite, a child, or in a wheelchair.

SPECIFICATIONS FOR ACCESSIBILITY

The Americans with Disabilities Act (ADA) Standards for Accessible Design provide detailed requirements for making exhibits accessible and safe for people of all abilities. The following specifications must be considered in your floor plan or case design:

- Wheelchairs need at least 36 inches width for aisles, 32 inches width for doorframes, and 60 inches for turn around.
- Maximum forward reach height for someone in a wheelchair is 48 inches.
- Protruding objects (floating wall-mounted cases or objects) should be no more than 4 inches deep, or have some type of rail below them to warn a blind person of the obstruction at a low (cane) level.
- Slopes, such as those that occur where floor surfaces change, must be beveled if they are less than one-half inch, ramped if more.
- Carpet must be securely attached and made with a level loop or level cut pile no more than one-half inch thick. All edges must be trimmed and securely fastened to the subfloor below.
- In a stage or lecture area, assistive listening systems should be provided.
- Directional signage (and text that orients visitors to the main sections of your exhibits) should have lettering at least 3 inches in height. Eggshell, matte, or other nonglare finish is preferred, with maximum contrast between letters and background preferred (very dark type on light background, or very light on dark).

The ADA standards document is available online at www.ada.gov and includes detailed diagrams of many types of structures with specific measurements. There is also a section on exemptions and allowances for designated historic buildings.

As visitors approach a wall or case, it is most comfortable for the visual center of a piece to be somewhat *below* average eye level (it is easier to tilt your head down rather than up). Choose a visual center that is somewhere between 50 inches and 60 inches to accommodate viewers of all ages and heights. Similarly, make sure that touchables are between 30–40 inches off the floor—lower for small children—so that everyone can reach them.

Once your team has come to agreement on the floor plan or map that makes the most sense for your exhibit, create a final schematic that is specific enough to communicate a real sense of the finished order, relative positions, and individual elements within the plan. The floor plan should be large enough to accommodate these details, but small enough to reproduce on your copy machine (legal size or 11 × 17 inches). This way, you can easily make more copies to mark up, share with others, etc.

HOW LONG IS THIS GOING TO TAKE?

Another working document that should be created as part of the planning stage is a planning matrix for various phases of the actual design and construction. Again, this will evolve with your process; but if you have ever remodeled a bathroom or planned a move, you know that there are particular steps that are best taken in sequence. During a home remodel by one of the authors, it was critical to schedule delivery of the portable potty before the plumber took out the only toilet! You may have objects that need to be restored before they can be mounted in cases, or cabinets that need to be refinished before they can be moved into place. Perhaps there is a donation of a specific component that needs to be arranged before work can begin.

Develop a planning matrix and calendar that defines specific tasks and assigns deadlines. Group objects with similar needs for mounting, restoration, and

SAMPLE PLANNING MATRIX	
Area: 1 (or whatever designation makes sense to your team)	
Object/Item #1: 8 Large glass plates	**Date/Week of Completion**
Restoration/mounting (describe): washing, purchase wall plate racks	Week 3
Interpretive support materials: (describe) history of plate factory	Week 2
Installation (special materials, equipment, skills): mount racks	Week 6
Additional notes:	
Estimated hours for completion: 8	Assigned to: Joe
Object/Item #2: Dutch oven	**Date/Week of Completion**
Restoration/mounting (describe): none*	
Interpretive support materials (describe): uses? recipes?	Week 2
Installation (special materials, equipment, skills): none	
Additional notes: *surface rust okay for display*	
Estimated hours for completion: 2	Assigned to: Anne

installation. Assigning a number to each object or grouping gives you a shorthand notation for your planning calendar.

From this matrix sample we identify tasks for Joe (washing, purchasing, research, and hanging) and for Anne (research). Joe may not be on the installation crew or be writing the labels, but he can be considered the caretaker of the object and its supporting materials. He can help the writer by getting his research in on time. And in Week 6, he can make sure that the hangers are there, along with the clean plates, on the day they are needed.

We also know that Anne can be a little creative with her interpretive materials (the question marks invite more discussion or thought) and that she should *not* spend time cleaning the surface rust off the pot to make it shine like new! Many old pieces invite "cleaning up" by their appearance, but decisions on restoration should be left to a conservator or other expert.

This division of labor serves two purposes: to distribute the work among a number of project team members (and volunteers) and to give participants a sense of significant responsibility and ownership. For volunteers, it is more satisfying to have a clearly defined, responsible role than only be asked to complete random, low-profile jobs.

See Worksheet 5C for a planning matrix.

If you've ever been in a large production facility, such as a printing plant or contractor's office, you may have seen one of those calendars with handwritten dates, where users can write with dry-erase pens to schedule and plan large projects. If your exhibit is fairly complex, buy one of these calendars for your workspace and use it to plan and track the various tasks that you've outlined in your matrix. If you are an enthusiastic user of these tools, you may want to color code the different areas of the project to show how they fall week by week.

Some weeks may be crowded with obligations, while others are relatively quiet. In our example, Anne and Joe may want to coordinate their trip to the archives and library. Realistic time estimates and distribution of tasks are essential to keep large exhibit projects on track. Even for a smaller display, it is helpful to have a well-defined calendar for all to share.

CALL IN A SPECIALIST!

As you work on your matrix and calendar, it will also be helpful to keep a list of specific needs as you identify them. For instance, you may realize that you will need to recruit a handy woodworker to help repair, build, or modify a cabinet. Find an electrician to install lighting, and locate a skilled proofreader to review your exhibit text. Or you may realize that the galleries need a fresh coat of paint and the local paint store owner is a regular visitor who might be willing to donate supplies. See chapter 9 for more ideas about pulling together the right combination of professional, volunteer, and donated resources for your display.

These needs will evolve as you progress through the design and fabrication process. It's essential to record ideas about these practical matters as you go, especially if the project is complex. You may also use Worksheet 5D as a list of supplies and skills that are already available within your museum's inventory, team members, and volunteers. Make sure that favorite pedestal isn't scheduled to appear in more than one area of your exhibit, unless you have a carpenter that can build more for you!

Use Worksheet 5D to keep track of items or areas of the exhibit that need special attention—skills, materials, and funding—for completion. Identifying these missing elements as early as possible allows your team, volunteers, and board to help recruit additional resources or offer assistance in a timely manner.

SHARING YOUR PLAN

Once the team comes to some agreement on a plan that seems both practical and effective for your message and audience, it is time to share your ideas with some key consultants—representative stakeholders in your new exhibit. By getting the plan out to your board, volunteers, community, and other stakeholders, you create an opportunity for them to make a further investment in the decision-making process. An even more important reason for this step is to identify

Your calendar might look something like this:

Object	Week 1	Week 2	Week 3	Week 4	Week 5	Week 6
#1 plates		research J		Buy racks, clean		install
#2 oven		research A				

Planning Matrix

Area: _____

Object/Item #	Date/Week of Completion
Restoration/mounting:	
Interpretive support materials:	
Installation:	
Additional notes:	
Estimated hours for completion:	Assigned to:

Object/Item #	Date/Week of Completion
Restoration/mounting:	
Interpretive support materials:	
Installation:	
Additional notes:	
Estimated hours for completion:	Assigned to:

Object/Item #	Date/Week of Completion
Restoration/mounting:	
Interpretive support materials:	
Installation:	
Additional notes:	
Estimated hours for completion:	Assigned to:

important practical sources for the next phases—design and construction.

Depending on the scale of your plan, you will likely have a number of practical considerations at this point. How much will this cost? Who will actually do the work? How much time will it take? Your stakeholders will ask the same questions. So before you take the drawings of your plan outside the team, prepare some talking points. Then when someone asks a tough question, you'll be prepared to answer in an organized, informed way. Throw in a little enthusiasm and they'll be signing up to help!

Review your worksheets from this and previous chapters—1A Take-Home Messages, 2E Multiple Per-spectives, 3C Interactives, and 5A Preliminary Exhibit Gallery Outline—to make sure your talking points accurately reflect the goals of your makeover. Worksheet 5E lists some talking points.

The answers to these key points also provide an outline for your exhibit prospectus (see chapter 9), or the introduction to a written document you may prepare for grants or potential sponsors and donors.

With the exhibit gallery outline in place and the design plan sketched out, the Exhibit Makeover Crew is ready to begin the actual design of your exhibit gallery makeover. Chapter 6 is your step-by-step guide to this creative process.

Identified Needs

Area/Object	Skills Needed	Materials Needed	Budget	Source

Talking Points for Your Design Plan

From the early process: for those who haven't been involved before or may need a reminder (e.g., a new donor prospect):

- How does this plan address the museum's mission?

- Who are your target audiences?

- What are the goals of the exhibit?

- What are the key messages?

For those who already know the big picture (e.g., a board member):

- What will this exhibit feel like for the visitor? Be prepared to describe galleries of thought/key messages and show how visitors will move through the story being told.

- What have you discovered about your museum/collection while working on this display? How will you share these insights with your community?

- What special skills, materials, and components will your museum staff need help with?

- How much will this cost and how long will it take?

- Is there a promotional component?

Design Your Exhibit Gallery Makeover

BUILDING FROM THE PRELIMINARY EXHIBIT GALLERY outline (Worksheet 5A) and design plan talking points (Worksheet 5E), in this chapter the Exhibit Makeover Crew will work together on an improved design for a gallery-size exhibit.

Exhibit design is a process of taking an often disparate group of facts, objects, and ideas and packaging them visually to tell a story. To accomplish this, exhibit designers rely on an extensive bag of tricks, simplified here into four neat categories—composition, mood, typography, and interactives. While entire books are written on the theory and practice of design, what follows is an abbreviated approach to presenting your pieces in an effective way.

Gather your worksheets and resources and let's begin!

COMPOSITION

While it can be a complex topic for artists or musicians to discuss, composition is simply about the arrangement of things. From your exhibit objects, words, interactives, and display cases, the relationship among the various pieces has a great deal to do with the perceived character of your exhibit. You've already begun the process of composing your exhibit by creating a floor plan or map. Now let's look at some simple examples of different styles of composition for your objects so you can get a feel for which style might fit your plan (figures 6.1a–6.1c provide examples).

Formal

Think art gallery or the traditional insect collection:

- **Adjectives to describe this style:** Symmetrical, even, reverent, stuffy.
- **What visitors see:** Most materials are presented at eye level (3–5 feet high).
- **Best for:** Very precious objects (formal says "don't touch!"), small objects with fine detail that require close viewing to appreciate, and similar objects that require comparisons without distractions in order to pick up subtleties.

Casual

Think retail store windows or informal restaurant décor:

- **Adjectives to describe this style:** Playful, approachable (even touchable?), friendly, realistic, relaxed.
- **What visitors see:** Elements are hung from the ceiling or piled on the floor (with the appropriate level of protection). Objects are approachable, or combined in unusual, thought-provoking ways.

Figures 6.1a–6.1c. From left to right—Sketches of formal, casual, and dramatic compositions demonstrate how the same subject matter can be presented with different visual styles.

45

- **Best for:** Presenting items that most people can relate to their everyday world, engaging those who might be put off by the formal, traditional art-gallery setting, making complex or technical topics more approachable.

Dramatic

Think opening night of the Olympics or a Broadway musical:

- **Adjectives to describe this style:** Bold, eye-popping, powerful, dynamic.
- **What visitors see:** Oversized elements, whether large objects or enlarged components, will be the pieces that even the speediest streaker won't miss.
- **Best for:** Entrances, exceptional singular pieces, a break from a long series of similar pieces.

The stunning beauty and enormous cultural value of Queen Nefertiti's painted limestone bust makes an unforgettable impression on even the most uninterested art viewer when floating dramatically on a black pedestal in a black room with a brilliant spotlight. There should be a little of this in all exhibits—this quality sets a stage, whets the appetite, and brings people into the space.

MOOD (COLOR)

While paint on the wall may leap to mind, consider a much broader definition of mood or color when you are creating an exhibit. Papers, fabrics, case linings, objects, ceilings, and floor materials all contribute to the mood and color of a space. Revisit the idea board you put together earlier, and expand your range of options.

Some key elements to consider are:

- **Your existing objects:** Is there an overall hue or group of hues inherent in the objects themselves? For instance, when working on a display about World War II Marine uniforms, a designer is confronted with a veritable rainbow of olive drab and khaki.
- **Surface textures:** Ranging from paint and flooring to lighting and backdrops for objects. Some of these may be determined by your existing structures, but economical options, such as paint and fabric, may add a fresh dimension. A dramatic change in texture or color marks a break in thought or a distinct section of a story, while a subtle progression evokes the passage of time. Patterns of carpet color or texture can define a path to follow or a place to gather on the exhibit floor.

- **Accents:** These may be bold as a spotlight or subtle as a piece of music playing softly in the background. Think of these as the romance in your design, the element that pulls viewers to a place or focuses their attention in the moment with a very specific message. Accents complement surface textures by creating powerful focal points throughout the journey.

Depending on the size of your exhibit, you may have several mood areas within the exhibit space. For instance, galleries or sections of cases may have a specific mood or color that separates one from another. Mood elements are powerful ways to either divide or unify groupings. Keep a set of color and material swatches on hand as reference for the mood of each exhibit section in your planning area.

TEXT AND TYPOGRAPHY

Writing text and selecting typefaces or fonts for an exhibit are two of the most important—and troublesome—areas of exhibit design. Clear, concise copy is critical to the viewer's enjoyment and understanding. Chaotic, illegible type and sloppy writing are distracting and frustrating to your audience.

While you may be tempted to share everything you know about an object or event, try to remain focused on the most essential elements that convey the romance and the key points of your storyline. Use headlines, tag lines, text, subheads, bulleted lists, and sidebars to break text into easily digestible chunks. A balanced exhibit will have roughly equal amounts of text in each section—keeping word counts can be helpful here. Seeing a section that is particularly text heavy will send most visitors quickly on their way to the next gallery.

- **Section headline:** A brief, bold statement engages viewers with each gallery of thought as they approach. Develop a headline for each theme area or division within your space. To allow streakers to read as they walk, follow the advice of billboard advertisers: no more than seven words in a headline. Use fewer words if you can. Rely on verbs and powerful adjectives.
- **Tag line:** Also called a subhead (and known in the newspaper field as a deck head), the tag line appears next to or under the headline, to clarify or support the main concept. Ideally, visitors can understand the key concepts just by reading these two levels of the text. Most streakers won't read anything else.
- **Introduction:** If the headline and tag line are interesting, the casual viewer may stop to read this bit of copy next. Keep the strollers' attention span in

mind here—they are not going to stand for more than a few minutes to get the point, and so are likely to only read a few lines of text. The introduction should be brief and compelling, enabling the reader to get a key concept along with intriguing details that support the take-home message.

- **Additional body text:** For the studiers, you may want to provide a limited amount of technical, detailed information about the concept. Again, consider whether this information may be better portrayed in graphs, captions, or even an interactive component (they are not just for kids!). But if you feel that text is the way to complete the message, by all means include text that is as brief and to the point as possible.

Avoid jargon and technical terms—you are writing for a broad audience. Reserve in-depth discussion of a topic for a brochure or gallery guide, a changeable exhibit notebook, or a discovery drawer. Plan related education programs (lectures, tours, film showings, etc.) and make sure visitors know about them.

Revisit Worksheets 2F and 2G and add a column about explanatory text (captions, labels, etc.) to each item. Assign one or more writers to develop text for each gallery of thought.

MAKING THE TEXT LOOK GOOD

While fine typography (the study of letterforms and their relationships) is an art form in itself, some general rules will help you use type effectively in your display. Each of the levels of text described above should have its own typographic style. This typographic hierarchy allows the viewer to easily browse through the sections and find areas of interest.

For typography and design, simple is usually better. Great typography is subtle, so subtle in fact that most people don't recognize it when it is done well (look carefully at a really expensive architecture or fashion

magazine or coffee table book for examples). The amateurs are easy to spot; it's the local community group newsletter that has a different font for every headline, text block, caption, and byline. And let's not overlook their designer's mastery of the gee-whiz-special-effect drop shadows, outlines, gradients, and screens. Avoid these—you don't need them. They clutter your message and detract from the undivided focus your collection deserves.

At the same time, don't forget the more subtle options that make your type stand out. A little bit of color, or a border drawn with a fine line, can give an air of formality or completion to your text panels. Find samples you like and don't be afraid to copy them!

For your exhibit title, use an eye-grabber that marks the beginning, starting point, or entrance. This may be a display font that is fancy, or very simple and elegant—something that looks nice and fits with the style of your objects and the period you are representing. Your sample board may provide some inspiration for a type style that would work well here. Look through the ephemera in your collection for something (a label, book, or sign perhaps?) with a special feel to it. Browse the Internet for many excellent websites devoted to type styles; you will likely be

Serif fonts have little
pointy feet, and are legible in all sizes and settings.

Sans Serif Fonts
are modern and clean, and many are also quite legible in both text and headline settings. They are often used for captions and charts, or anywhere that a bit of information needs to be distinct from the main text.

DECORATIVE FONTS
can be difficult to read, but for a few words (e.g., a title) or to portray a specific historical period, they can provide effective emphasis. Do a little research and use these carefully!

Figure 6.2.

able to match your historic sample to a currently available font.

Your exhibit title can be as simple as a group of words in a distinctive style and color, or it can incorporate a symbol or graphic embellishment along with the lettering.

Don't go overboard in your desire to add meaning and style with an interesting font or symbol. Too many tricks and flourishes will clutter up your message. Let your words speak simply and powerfully with little or no ornamentation. A general rule of good design is that if the added element, color, or arrangement of the type (or graphic) does not add to or clarify the message, throw it out.

BUTTERFLY:
VINTAGE COLLECTIONS

Butterfly

Butterfly

Figure 6.3. Fonts have personalities ranging from serious to whimsical, and are often associated with a particular time period. Choose a title font carefully to reflect the storyline and appeal to the intended audience.

Also when designing a title, consider where most visitors will be (their distance and angle of view) as they approach this beginning point. Visitors must be able to locate and read the exhibit title from the farthest point in the space—think of it as a way-finding tool! If your exhibit gallery has windows, and especially if it fronts a street with lots of foot traffic, consider orienting the exhibit title toward the front window, repeating it in a place that is visible from the street, or making an outdoor banner with the title graphic on it.

For very large exhibits, repeat the title as a graphic element in other areas of the galleries. This helps any visitors who missed the entry point, and provides a visual thread to reinforce the overarching theme of the exhibit.

- **Section headline:** Depending on your title font, this could be the same font in a simpler setting (no symbols or embellishments). Section headlines should also be visible from a distance—casual visitors can use them to find their way to specific areas of interest, or follow a chronological sequence.
- **Tag lines:** These should be clean and simple, often contrasting with the headline font but always smaller. Changes in font size automatically invite visitors to move closer. The next level of text is even smaller, for the same reason. Once people begin to move toward your point of central focus, you have captured your audience! Reward them with a nice detail as they are drawn into the area (e.g., smaller objects, intriguing illustrations, or an interactive experience).
- **Body text:** Two or three paragraphs of deeper content, aimed at the studiers. Choose a font with serifs. Bars at the top and bottom of letters make serif fonts easier to read than sans serif typefaces. Type size should be at least 18 points. This allows for easy reading at close range for those with 20/20 vision and increases the odds of readability for people with any compromised visual ability.

Black type on a white (or very light) background is easiest for visitors to read. Gray type, or color type on a colored background, presents difficulties even for people with 20/20 vision. Reverse type (white letters on a very dark background) is also tiring for readers, so use this effect for short headlines, graphic titles, or tag lines. Finally, you may be tempted to place type over a ghosted or faded background image, but again, you must be very careful with this technique. Think of the background as a subtle texture, rather than an image, and be sure that it is soft enough that it doesn't interfere with the text.

- **Captions:** These describe or explain objects or images; they range from a name and date to a sentence or two about the history or relevance of the object. These brief text blocks are always set in a style that is distinct from the narrative text. Designers make this visual distinction for two important reasons. (1) Captions provide a different thread of content; many visitors will seek these out (just the facts, ma'am) before reading the interpretive text. (2) Since captions are often interspersed with the other text elements on a wall, they must be separated typographically to keep readers from confusing them with part of another text block.

Captions are usually about the same size as or slightly smaller than the body text. Rules about typeface color and contrast also apply. You'll find great examples of captions in *National Geographic* magazine. Their captions are typographically distinct, and they consistently motivate readers to look closely at the photographs.

FILLING THE HOLES

Just as you have a large headline that grabs folks from across the room, you will also want an object or image that pulls visitors into the gallery. You may be lucky enough to have a large, iconic item on your must-display list—a beautiful antique car or a mannequin with an exotic costume that captures the imagination of everyone who sees it.

But what if you only have the butterfly collection, with no specimens larger than six inches across? Technology to the rescue. Choose your most romantic, compelling, dramatic, exciting object. Or find a very simple object to create a mood through a shift in size or color. Use a digital camera or a scanner (depending on your object's frailty and size), to capture a high resolution image of the piece you want to enlarge. From this digital file, create a poster-sized (or larger) graphic to serve as a visual "banner" that calls out to visitors from across a room. Don't limit yourself to one—a series of large graphics can provide an easy-to-follow visual orientation for your audience.

Charts, graphs, and other illustrations can also complete the story (e.g., comparison of statistics, progression of time, life cycle, or stages of development). For excellent examples of ways to approach this type of information, see any of Edward Tufte's books on information graphics (appendix A). Select the best storytelling information graphics. Draw visitors' attention to these rich resources by giving thought to color, placement, and size.

RESOLUTION OF IMAGES

These days, we work almost exclusively with digital images measured in pixels per inch (ppi). The ppi data is important because it determines the quality that you can expect for reproduction. Images of 72 ppi are common—they display beautifully on a computer screen but show as jagged or "pixelly" when printed on paper. The pixels are not visible when you print an image at 144 ppi or higher. To understand how this might affect images in your exhibit, here are three examples you might encounter. You'll need an image manipulation software program to read your image size accurately, or ask your image output supplier to look at your files with you.

- **A photo from a camera:** A photographer took a high resolution image of an event. The file is 27 × 16 inches at 72 ppi. By downsizing the image to half the measurement, or 13.5 × 8 inches, you can double your pixel count (2 × 72 = 144) to 144 ppi. This will be the largest size print you can make with this photo and have it look crisp.
- **An image from the Web:** You've gotten permission to use another museum's photo to tell your story and they send you to the website to download the image. The file is 3 × 4 inches at 72 ppi. This looked great on the computer screen, but you'll need to downsize it to 1.5 × 2 inches before it will look good in print. Ask them if they have a higher resolution image that they can send by e-mail or on disk. Specify your computer platform preference—Mac or Windows—and the type of disk so you can open it on your equipment. Provide the desired finished size of the image (how large you plan to print it) so they can provide you enough pixels to work with.
- **Scanned images:** If you have access to a scanner, or can find someone to scan for you, you will have much more control over your image's final reproduction size. You'll need to do a little math here with what experts call the "pixel dimension," but the results will be worth it! If you have an 8 × 10 inch photo, any reasonably good scanner will allow you to choose a resolution of 800 ppi (or more). At 800 ppi, the image measures 8 × 800 or 6,400 pixels across. Divide this by 144 (our target resolution) and you'll find that the image can be reproduced at 44.4 inches across. That's big! Don't be surprised when the file size of your image is shown in megabytes (M) rather than kilobytes (K)—large images are also large data files.

Other options for transforming small objects and images into attention-getters include adding a mat or frame, grouping related objects, and displaying multiples. Even the simplest object can take on a new life through some creative filtering in image manipulation software. Remember Andy Warhol's soup cans? There are filters in image programs that allow you to restyle photos with textures that mimic paintings, drawings, and graphics. You can even add motion to images and three-dimensional effects to type.

NARROWING THE FIELD

As you are finalizing placement of objects, you may find that not everything will fit. If an object, graphic, or other element does not add an important piece to the story, it needs to be cut. Similarly, if you have plenty of space and an exhaustive collection of (fill in the blank) to fill it, odds are that the endless variations of (blank) will not be as fascinating to your audience as it was to the collector who gathered these together. Sometimes exhaustive is simply exhausting. Remember that most museums only display a small portion of their total collection, so keeping a portion of the (blanks) in the vault is an accepted and practical solution.

Organizational tip: After each round of rebalancing, resizing, and editing, you should revise your master floor plan. Maintain a clear and accurate record of the latest decisions and current vision as you prepare to construct and install your final version of the exhibit.

Chapter 7 will lead the Exhibit Makeover Crew step-by-step through this culminating phase of your gallery makeover.

Build and Install Your Exhibit Gallery Makeover

GUIDED BY THE STEP-BY-STEP INSTRUCTIONS IN THIS chapter, the Exhibit Makeover Crew will produce and install the elements of an improved exhibit gallery.

A well-planned installation can be one of the most rewarding—and exhausting—stages of the renewal process. Seeing all the pieces come together and being able to enter and walk through a new display for the first time can be an extremely satisfying moment. On the other hand, as with home improvement projects you may have experienced, there are often not enough hours in the day to accomplish everything you set out to do. A team member on sick leave, misplaced equipment, a difficult mounting process, or a forgotten specialty drill bit can throw the schedule (and your nerves) into a spin. Assign a cushion of extra time (typically 20 percent) to each task to allow for unplanned interruptions and complications.

While every exhibit has its special challenges, the following background on materials and processes will help the novice installer think through some options and procedures to make the job run smoothly.

CONSERVATION

With any project involving original artifacts, the museum's first priority should be to protect and preserve items for future study. Therefore, conservation issues should be first and foremost in the mind of anyone involved in the handling or mounting of artifacts. Standard procedures should include:

Wear white cotton gloves while handling artifacts. Some materials, such as paper and fabrics, absorb skin oils, which contribute to long-term chemical deterioration. Less porous materials may require additional cleaning if handled without gloves; repeated cleaning is detrimental to many surfaces.

Avoid using display materials that produce volatile organic compounds (VOCs). Paints, glues, and carpets are three commonly used materials that may be hazardous to the health of your artifacts unless you specify low-VOC products. Off-gassing is easily detected when a newly installed material has a "new smell" (new car smell is actually a potent blend of

VOCs

Volatile organic compounds (VOCs) are emitted as gases from certain solids or liquids. VOCs include a variety of chemicals, some of which may have short- and long-term adverse health effects. Concentrations of many VOCs are consistently higher indoors (up to ten times higher) than outdoors. VOCs are emitted by a wide array of products numbering in the thousands. Examples include: paints and lacquers, paint strippers, cleaning supplies, pesticides, building materials and furnishings, office equipment such as copiers and printers, correction fluids and carbonless copy paper, graphics and craft materials including glues and adhesives, permanent markers, and photographic solutions.

For more information about VOCs and indoor air quality, visit the EPA's website (www.epa.gov).

vinyl, carpet, and upholstery with a little paint and wax on the side). Other gases may be imperceptible to our noses yet be chemically active in your display. Many laminate wood products consist of layers of wood held together by synthetic or natural glues that release harmful gases for a prolonged period. Trapped inside a display case or sealed room, these chemicals have the potential to react with many objects (not to mention your visitors and staff). To be safe, use low-VOC materials throughout your gallery spaces.

Remove your artifacts from the construction zone. Galleries undergoing installation are construction sites—potentially hazardous both to installers and to museum visitors. Keep visitors out with yellow hazard tape or barricades. Artifacts are also in danger; a minor accident such as a dropped tool or the bump of a ladder could result in scarring or worse for your artifact.

Use physical barriers between guests and untouchable items of value. You may be reusing glass cases or bookshelves, or building custom pedestals for displays. Be honest about the worst possible situation that might arise (the running toddler, the earthquake, the thief) and secure your cases, dividers, and artifacts accordingly.

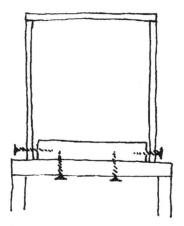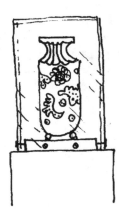

Figure 7.1.

Simple, custom Plexiglas boxes can fit over a board (see figure 7.1) that secures with screws. Use an unusual screw head to deter the casual, multitool-carrying thief.

Glass cases may need safety stickers (a thin line of adhesive vinyl can be subtle and effective) to remind visitors that the glass is there. If large panes of glass are at floor level, consider a change in floor level, a rope stanchion, or a bumper to protect strollers, wheelchairs, and average klutzes from potentially nasty accidents.

MOUNTING

Once the walls and floors are in place, you face the daunting task of getting everything held in place on the walls (and perhaps even the ceiling!). A huge range of materials is available for backgrounds, display panels, and wall units. Described below are several of the most common ones available. Check with your local art or craft supply stores, frame shops, and hardware stores; it's convenient to buy from local suppliers. The Internet is also a great place to shop for specialized materials, but the limitations of your monitor's display may make subtle color choices difficult and textures invisible. Also, if you run out of a material, you may face delays waiting for additional items to be delivered.

Matboards

Museum board or acid-free matboard is a dense, high-quality cardboard familiar to custom framers

> **Plexiglas** (plexi) is an important fabrication tool for protecting valuable or fragile objects, but it needs special handling. Place a piece of masking tape in the location where holes are being drilled. The tape keeps the plexi from cracking. Wipe plexi with cleaners made for plastics and very soft cloths to prevent scratches.

> **ARCHIVAL MOUNTING MATERIALS**
> Many of the common papers, glues, tapes, and plastic sleeves that are found in your local art or office supply store are not suitable for use near your valuable artifacts. The chemical compounds used to make inexpensive supplies can cause interactions that discolor, pit, or otherwise damage delicate papers, photographs, fabrics, and other organic artifacts over time. Look on the Internet for sources of archival quality art supplies and to get ideas for products that best suit your artifact's display needs.

and available at your local frame shop or art supply store, usually in a limited range of colors. It is suitable for matting papers or photographs that require an archival environment.

Foam Core

Available in acid free, nonacid free, and self-adhesive varieties, foam core also comes in a spectrum of thicknesses and densities. Standard colors are black and white—some suppliers offer a limited range of bright colors. Inexpensive foam core has a less dense filler, so it is prone to dents and dings. High-quality foam boards are sturdy enough to use as structural elements (e.g., a small pedestal within a case or a small box shelf). All foam core boards are lightweight and easy to trim with an X-Acto knife, box cutter, or jig saw (specialized cutting tools are also worth looking into if you have a large number of complex cuts). Foam board's light weight makes it easy to adhere to other surfaces with a variety of glues and tapes or suspend from a ceiling. Plastic trim can be added to protect the straight edges from dents.

Self-adhesive foam boards are precoated on one side with either permanent or repositionable adhesives (a convenient and environmentally friendly alternative to spray glue). These are great for larger panels, as well as for cutout photos or letters that add a little depth to your wall. Identification labels also look nice mounted on foam. A simple easel back for graphics or text can be constructed for items sitting in a cabinet or case (figure 7.2). Check with your supplier to determine which weight will work best for your project and what acid-free adhesives are available.

Structural Background Panels

Large panels are often used as a visual divider or dramatic entry point. These panels can also be mounted to create depth on a wall and provide a sur-

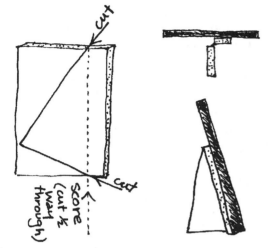

Figure 7.2.

face that is convenient for attaching objects (see figures 7.3a and 7.3b).

A simple, low-budget option is an acid-free composite board, sanded and finished with a nice routed edge,

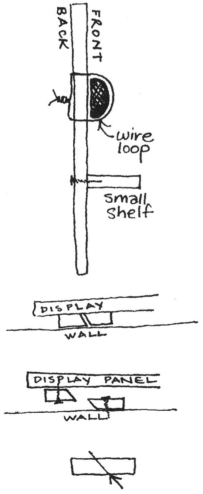

Figures 7.3a and 7.3b.

and painted with some low-VOC paint in your exhibit's color scheme. Use a projector to project your graphics and trace them in pencil, then hand paint the image with good quality acrylic paints. Add neat, foam-core-mounted text panels and objects to complete the display.

If handwork isn't one of your team's strengths, consider purchasing custom-cut vinyl type or graphics from a sign shop. These vinyl sheets are self-adhesive and incredibly durable (suitable for outdoor applications as well), and the supplier usually applies them to your panels for you. (Cut vinyl is also available from online suppliers catering to both the interior design and signage trades.)

The ultimate material—combining high-resolution color quality and a durable surface—is digitally imaged high pressure laminate (DHPL). Available in a variety of thicknesses and surface finishes, this product comes with a ten-year guarantee. For this option, you send off a graphics file (as large as you like), which is output on a large, high-resolution color printer and then sandwiched between layers of melamine and phenolic resin (similar to Plexiglas). The whole piece is placed in a high-temperature, high-pressure press where the melamine melts and seals the graphic into the sheet. The high price tag means that this process should be considered for permanent displays or those requiring an exceptional amount of durability.

Professional Mounting Options

Some photo processing businesses offer mounting and laminating options. Dry mounting is a process where a thin piece of adhesive tissue is sandwiched between foam core and your reproduction photo or graphic panel (never use dry mounting for an original two-dimensional object from your collection). Laminate coatings may also be added to protect your graphics from smudges and moderate moisture.

Nonarchival Options

Some areas of your display may not include original artifacts (e.g., an introductory panel of digital photos and text created for the display without any "real" pieces from the permanent collection). Without conservation concerns, you have considerably more options for papers, matboards, and materials.

Standard framing matboard is not generally acid free—but it comes in a wonderful array of colors and textures. The popularity of fine-art bookmaking and the scrapbooking hobby has spawned an incredibly diverse range of retail papers. From handmade natural fibers to themed prints and metallics, papers can

provide an elegant, inexpensive accent for your text or graphic panels.

Look for texture in unexpected places! Perhaps a fabric or bamboo screen would make an eye-catching backdrop for one area or wall of your space. Commercial wallpaper comes in a staggering array of patterns and textures. Fabrics should always be washed to remove any starches or other treatments that might be generally harmful to the museum environment.

THE SMALL STUFF

Once all the cases, backdrops, and major large panels are in place, it is time to bring out the artifacts and begin placing them along with their labels and any other small elements. While many things may seem perfectly stable held in place by good old-fashioned gravity, it is wise to consider that any piece could be bumped, wiggled, or jostled—whether by a clumsy visitor or an act of nature. Artifacts should be secured—with wire, tape, wax, or glue—in the least intrusive way (both visually and chemically) possible. Some examples might include:

- Ceramics or glassware held in place with a discreetly placed wire or bits of adhesive wax.
- Fabrics hung from a Plexiglas rod.
- Papers or photos mounted with acid-free tapes or photo corners.
- Lightweight objects supported by strategically placed pins around their edges (not through them!).

Plan as many of your mounting needs as you can before you begin the installation, and try to simplify as much as possible to make the process easy on yourself. For instance, if you have lots of foam core or fabric surfaces, you may want to rely primarily on a variety of pins to attach lightweight objects. Unusual-shaped objects may need wire or wooden armatures that can be made in advance.

Invariably, you will find a few objects that require a little more support or stabilization after your careful placement. These may be in tight places, so small tools or tiny bits of adhesive or pins may be the perfect fix. Be prepared by having a toolbox filled with a good selection of the following handy items.

The Installer's Tool Kit:

- *Tapes:* duct, double-sided foam, masking, painter's transparent, double-sided transparent, removable transparent, linen, acid-free cloth.
- *Glues:* carpenter's glue, glue sticks, rubber cement, superglue, hot-glue gun, acid-free paste, acid-free spray adhesive.

Many tapes and glues would not be suitable for use on your artifacts but are safe for creating support structures or mounting smaller display graphics outside your cases. Use only acid-free or archival products inside your cases whenever possible to avoid discoloring and toxic off-gassing. Look for these products in the book-binding or framing section of your local crafts store.

- *Tacks and Pins:* thumbtacks (quilter's oversize tacks are especially handy), push pins, map pins, T-pins.
- *Wire:* a variety of weights including florist, picture, extra-fine (e.g., jeweler's wire), extra-heavy (e.g., coat hangers). Cotton or nylon thread (fishing line) may be suitable for suspending or securing very lightweight objects.

Some of your mounting materials such as pins or wires may be visible at some angle of viewing. Don't despair—simply keep the materials neat and consistent (one or two types of pin or wire) and visitors will tune out these elements visually.

- Adhesive wax (often sold in the candle section).
- Plate or doll stands.
- Acid-free photo corners.
- Wire cutters and regular and needle-nose pliers (jeweler's size).
- A variety of screws and nails in addition to the size you think you need.
- A variety of picture hangers and hooks for wall-mounted objects.
- Scissors, large and small.
- Knives: craft knives, box cutters, single-edge razor-blades.
- Brushes: a variety of sizes for cleaning dust or painting.

- Binder clips to use as clamps in small places.
- Tweezers.
- Band-Aids (for you!).

In addition to these small items, be sure to have the following handy:

- Paper towels and lint-free cloths.
- Cleaning fluid: nonammonia glass cleaner or plexi-cleaner.
- A step stool or ladder.
- Weighted objects (e.g., a sealed glass jar full of sand or stone, wrapped in a neutral cloth, or nicely finished wooden blocks) to raise or provide a solid prop for an artifact.
- Spare scraps of foam core for cutting a last-minute easel back or prop for a light object.
- Cordless drill/driver.
- Small vacuum cleaner.

Collecting your tools will require visits to a variety of stores, including art and craft, hardware, office supply, and specialty retailers both in your community and online.

Look at this as part of the adventure, and collect ideas for future makeovers or improvements to existing displays as you go!

When the Exhibit Makeover Crew is ready to take the next step, turn to part 3: Involve Your Community. In chapter 8, discover ways to recruit community volunteers for a makeover of your entire small museum. For ideas about how to make the most of your exhibit or museum makeover on opening day and beyond, see chapter 9. Find out how to collect feedback from visitors, and how to keep your gallery clean, well-maintained, and continually fresh.

You'll find more museum-wide tools and resources in appendix A.

INVOLVE YOUR COMMUNITY

A Small Museum Makeover

YOUR EXHIBIT MAKEOVER CREW HAS SUCCESSFULLY completed a gallery-level exhibit, and visitors are enthusiastic. Congratulations! Now you are ready to strengthen skills you've learned and practiced, while adding some new skills that will help you with an even more ambitious project. A small museum makeover offers an exceptional opportunity to engage a cross-section of your community as active participants in exhibit development.

Community involvement is an essential step toward making your museum a beloved institution, valued by the community because of the unique and essential services it provides.

To ensure the museum's lasting value, consider how visitors will experience your building, exhibits, and programs. To get the best information about that, invite visitors (and nonvisitors) to be part of your planning process. Leading community-based museums throughout the world have discovered the important benefits of involving the community. These may include a richer exhibit program, increased attendance, new audiences, and increased support by members, volunteers, and donors.

ASSEMBLING YOUR MUSEUM MAKEOVER CREW

The core Exhibit Makeover Crew, made up of three museum insiders, worked together on the makeover of a single-case exhibit (chapters 2 and 3). An expanded Exhibit Makeover Crew of 10–12 people, including board members, volunteers, and other museum stakeholders, created a successful gallery-level exhibit makeover (chapters 4–7). You've learned to work as a team, and together you've accomplished great things.

For a makeover of your entire small museum, transform your in-house Exhibit Makeover Crew into an expanded Museum Makeover Crew by adding 10–12 community members. Aim for a balance of museum insiders and community members, to ensure lively, genuine dialogue.

To identify people who might be persuaded to volunteer for the Museum Makeover Crew, ask such questions as:

- Who knows the stories we might tell?
- Who represents viewpoints and experiences that have been missing or downplayed in our museum?
- Who has time and expertise needed to accomplish our transformation?

Some new Makeover Crew members may have been involved in earlier makeover projects as resource people. Others may be new to your museum. Don't expect individuals to "represent" a particular viewpoint or affiliation. Instead, look for knowledgeable and respected people who are willing to participate in planning, and who have the potential to engage with the planning process.

You may need to do extensive research to learn who these people are. You might begin with informal contacts, leading to invitations to participate in one or more focus groups. Some members of the group may be interested in serving as content advisors to the Museum Makeover Crew, or as full-fledged Makeover Crew members.

Although you may eventually divide into a number of subgroups to focus on different aspects of the museum makeover, you'll first learn to work as an expanded team. The challenge for the original Exhibit Makeover Crew is to open your process to perspectives that go beyond the museum's inner circle.

In this chapter you'll engage in a series of team-building and process exercises for the Museum Makeover Crew. Together, you'll share museum memories, discover common ground, and use differing viewpoints as a stimulus to creativity. You'll assess the effectiveness of your museum's exhibits and visitor services. Finally, you'll decide what kind of a museum makeover you want to undertake, and organize your Crew and resources to get it done.

TEAM-BUILDING FOR THE MUSEUM MAKEOVER CREW

Use Worksheet 8A to share personal experiences that will inspire and guide your planning efforts.

Creating Memorable Experiences

In a Museum Makeover Crew meeting, spend a few minutes reflecting silently about this question: Can you remember an experience in childhood or adolescence when you became aware of the existence of the past? Or saw the natural world through new eyes? Or felt a work of art capture and hold your attention?

Ask each person to share memories and reflections about these pivotal moments.

These are the types of experiences that we are trying to create in a museum setting. As a group, try to understand what your experiences had in common. Write down some guiding principles to make sure your exhibit will give visitors the opportunity to have their own "aha!" experiences.

Interpretation's Inventor: Freeman Tilden

Freeman Tilden (1883–1980) was a reporter, writer, and born teacher who discovered ways to engage city people with the natural world. Freeman Tilden used the word "interpretation" to describe exhibits and programs that help visitors connect with the subject matter. Tilden's definition of interpretation, first published in *Interpreting Our Heritage* (1957), is a touchstone of the exhibit makeover process: interpretation is "an educational activity which aims to reveal meanings and relationships through the use of original objects, firsthand experience, and by illustrative media, rather than simply to communicate factual information."

Compare Tilden's definition of interpretation with the principles and reminders you noted in Worksheet 8A. If you want, add language to the worksheet that reflects Freeman Tilden's interpretive approach.

A Little Romance: Alfred North Whitehead

British scholar Alfred North Whitehead (1861–1947) made his mark as a mathematician and philosopher. Along the way, he wrote essays on how people learn (see *The Aims of Education*, first published in 1929). Whitehead's ideas apply to people of all ages—and are very useful for planning exhibit experiences.

Whitehead believed that no matter how old you are, in order to learn something new, you must first fall in love with the subject matter. Dinosaurs, princesses, a basketball team, horses, a series of historical novels, nature photography . . . most people can point to a turning point that opened a door to a new fascination. Whitehead calls this mind-opening experience the stage of *Romance*.

When you fall in love with a person, everything about him or her becomes interesting. You want to know, "What is your favorite flavor of ice cream? Where were you living in the fourth grade? Do you like cats?" The same holds true when we fall in love with a subject. We are hungry for information, and every

piece of trivia is absorbed and memorized effortlessly. This is what Whitehead calls the stage of *Precision*.

Most kids who love dinosaurs don't grow up to be paleontologists. But their temporary passion may teach them that they can master a body of knowledge, or give them a sense that even the biggest and strongest critters may turn out to be fatally vulnerable. According to Whitehead, this is the culminating stage of learning: *Generalization* of a set of principles to other areas of your life.

Romance is *the* essential ingredient in exhibit planning. Visitors come to the museum in search of romance; they hope they'll fall in love with something. It's very frustrating when they run up against a welter of facts (e.g., a display case full of old tools) or a generalization ("Pioneer Tools"). Whoever planned the exhibit was already in love with those tools, but neglected to offer visitors the same opportunity to find romance. Worksheet 8B will help your Museum Makeover Crew put some Romance (in Whitehead's sense) into your planning efforts.

HOW WELL ARE WE SERVING OUR VISITORS?

Next the Museum Makeover Crew will work together to assess the museum's current exhibits and brainstorm ways to improve them. You'll study museum experiences from three viewpoints: multiple intelligences, visitor participation, and accessibility.

Multiple Intelligences

Research by Howard Gardner (e.g., *Intelligence Reframed: Multiple Intelligences for the 21st Century*, 1999) suggests that one important reason each of us brings a unique perspective to our experience can be traced to what he calls multiple intelligences. Think of your friend who can play any tune by ear on the piano, or another friend who draws or paints beautifully. A few three-year-olds can dribble a basketball up and down the court with ease. Math was a breeze for one of your classmates; another loved to write.

Gardner says these aren't just talents or abilities but full-fledged intelligences. This runs counter to mainstream usage, where the category "intelligence" applies only to linguistic and logical-mathematical performance. By integrating Gardner's range of intelligences with your exhibit planning, you'll enable more of your visitors to feel engaged—and intelligent!

Howard Gardner defines intelligence as "the human ability to solve problems or to make something that is valued in one or more cultures." Gardner has identified seven basic intelligences. Worksheet 8C asks the Museum Makeover Crew to brainstorm ideas for making your exhibits more appealing to people of all intelligences.

Visitor Participation

How can visitors contribute to museum exhibits? The opportunity to participate in meaningful ways is extremely rewarding to visitors. And museum insiders might learn something from what visitors tell them! Take a look at Worksheet 8D.

Accessibility

The requirements of the Americans with Disabilities Act (ADA) may sound difficult or oppressive, but in fact, they are liberating. They free the Museum Makeover Crew to take a bold design approach. For best results, try to involve all the senses.

You'll find that planning for accessibility will make your exhibit more effective for all visitors. By emphasizing visual imagery and three-dimensional objects (including many touchables), you can reach visitors who can't read (including most children under six, and many adults) and non-English speakers.

Everyone wants to touch a few things in the museum, and for blind visitors, it's essential to do so. Smells awaken all the other senses. Music and other sounds send a message of relaxation and welcome: you don't have to be quiet here!

Cater to the whole family. A bench with a good view can be a godsend to a grandparent or a nursing mother. A scaled-down rowboat or a (pretend) pony is unforgettable to a two-year-old (and her grateful parents). Artwork and video documentaries produced by students attract attention from teenage visitors.

Be very sparing with text. Remember, you want visitors to fall in love with your subject matter. A "book on the wall" is not romantic—it's a turn-off.

Combat museum fatigue! Predictability isn't romantic, either. Vary interpretive media, educational approaches, color and texture, and the pace of the exhibits. Use hot, neutral, and cool exhibit methods to energize visitors.

- **Hot:** A "hot zone" is anywhere visitors touch, hear, smell, or do something, or where their emotions are engaged.
- **Neutral:** Looking at a case full of objects or a row of pictures is often a neutral, observational experience—but depending on the subject matter, it can also be extremely emotional!
- **Cool:** Studying a timeline can be a cool, cerebral experience, unless you're already in love with the subject matter, in which case it can be totally engrossing.

Looking with Fresh Eyes

Schedule your whole group for an hour-long Exploration in your own museum or at another museum in your community. Meet in the museum's front entrance. Ask everyone to bring a pad or clipboard (for use as a writing surface) and something to write with. Give everyone a copy of the *Exploration* exercise below, and turn them loose.

EXPLORATION

Follow these directions one step at a time, without reading ahead.

1. Stand by yourself near the front entrance to the exhibit gallery.

2. Relax. Spend one or two minutes clearing your mind and using all your senses to become as attentive as possible to your environment.

3. Let yourself be drawn in any direction toward any one of the exhibit spaces.

4. Explore the exhibits until you find an object that you really like. Move around and look at this object from different points of view.

5. Make a drawing of the object. (Use blank side of this page.)

6. List any words that will help you describe the object to another person.

7. What are some questions you have about this object? List them.

8. How does this object make you feel?

9. How is it like you?

10. How is it different?

(© 2003 Alice Parman, Ph.D.)

When everyone has finished, go through the exhibit gallery as a group. Members of the Museum Makeover Crew take turns introducing their focus objects, along with the observations they recorded.

A general discussion can follow. What does the *Exploration* experience tell you about how visitors experience a museum? How could your exhibit help visitors explore, reflect, and share?

Revisit the Creative Warm-Up exercises in chapter 4, to involve the expanded Museum Makeover Crew in the exhibit planning process. After each exercise, debrief with the group. What parts were easy and fun, and what parts were more challenging? A person-by-person check-in is an effective way to find out what's working—and not working—for individuals. Sometimes the shyest people have the best

Multiple Intelligences

What can your museum's exhibits offer to people with strengths in the various multiple intelligences?

Type of Intelligence	Description	Examples of Exhibit Elements That Match Each Intelligence	Ideas for Your Exhibits
Verbal-linguistic	A person's way with words	• Bold first-person quotes • Opportunity to write • Opportunity to audio-record	
Logical-mathematical	Thinking and reasoning, use of numbers, ability to recognize concepts	• Solve math problems (e.g., to understand class differences or trade relationships) • Be a detective; solve a mystery	
Visual-spatial	Ability to work with objects and dimensions, and to see images in your mind's eye	• Opportunity to draw • Opportunity to design • Experiment with a hands-on model or replica (e.g., a model train or a towboat's control panel)	
Body-kinesthetic	Ability to express yourself physically and control your body (as in dance, athletics)	• Compare your body with an animal's body • Make your body look like someone in a painting	
Musical-rhythmic	Tuned in to tone patterns and sounds; responsive to rhythm and beat	• Background music • Musical elements (e.g., a song or instrumental performance • Play an instrument (e.g., drum)	(continued)

Type of Intelligence	Description	Examples of Exhibit Elements That Match Each Intelligence	Ideas for Your Exhibits
Interpersonal	Ability to communicate person to person and have relationships with others	• Board game • Game of skill or chance • Have a conversation about a thought-provoking question	
Intrapersonal	Capacity for spiritual exploration, self-reflection, and awareness	• Opportunity to leave testimony • Self-assessment opportunity	

ideas. How can you ensure that everyone has an equal chance to participate?

Worksheet 8E challenges the Museum Makeover Crew to get serious—and specific—about accessibility.

YOUR TARGET: PROJECT OUTCOMES

You've made the decision to devote time, energy, and resources to exhibit renewal. What are the intended outcomes of your project? How will your efforts benefit visitors, the community, and the museum?

An outcome is a tangible, measurable result that you want to achieve through your exhibit renewal project.

Worksheet 8F includes sample outcomes that a planning team might wish to achieve. Put a check by sample outcomes that match plans for *your* museum. Make changes, or rewrite completely, to suit your unique circumstances. Then brainstorm outcomes

Need help brainstorming outcomes that are right for your museum?

- Ask a colleague from a museum whose exhibits you admire.
- Network with members of your state and regional museum associations.
- Post an e-mail message on a museum listserv.
- Consider hiring an interpretive planning consultant to help you with this phase.

that the team intends to accomplish through your renewal project. (See chapter 1 for brainstorming basics.) Use Worksheet 8G to analyze and record the results of your brainstorming session.

After you've brainstormed all the benefits that might apply to you, identify your priorities. What are your top two outcomes in each category?

MEASURING SUCCESS

Next, for each priority outcome, determine how you will measure your success in achieving that result. Some examples:

- Increased attendance.
- More volunteers of diverse backgrounds (age, gender, ethnicity, etc.).
- Increased number of job applicants with better qualifications.
- Increase in individual contributions, foundation funding, government grants.
- More stories in the press and media.
- More visitors in family groups, more Spanish-speaking visitors.
- Positive evaluation of exhibit design by a qualified professional.
- Positive comments about exhibit "look and feel" by visitors.

Notice that each outcome's success is evaluated in terms of a tangible, measurable result.

Record your high-priority outcomes and measures of success on Worksheet 8G.

These project outcomes will guide the Museum Makeover Crew as you decide where to put your time, energy, and money. Some examples:

• Is improved look and feel your top priority? You may choose to begin by cleaning, painting, and refurbishing the exhibit halls, installing better lighting, and improving your directional and gallery signage.

• Is attracting new audiences your most important outcome? You might experiment with ways to persuade trusted opinion leaders from those audiences to become active members of the makeover crew.
• Is communication of certain messages, ideas, and facts first on your list? You may decide to enlist the help of scholars, elders, community members, and other experts as content advisors.

If you decide that several outcomes are equally important, you'll need to create an integrated timeline for planning and implementation that feels logical and doable to you. To boost your chances of success, recruit skilled volunteers, divide the Museum Makeover Crew into specialized working subgroups, and stay in constant communication.

BUILD YOUR SCHEDULE
After watching organizations in action, economist C. Northcote Parkinson formulated "laws" based on his observations. One of Parkinson's most useful laws holds that "work expands to fill the time available." With this in mind, don't set your exhibit opening too far into the future—but don't underestimate the

Accessibility Checklist

Review your current exhibits. Write down all the elements you've identified that will make your exhibit accessible. Then brainstorm ways to fill in any blank spaces on the worksheet.

Types of Visitors	Exhibit Elements Accessible to Them
Visitors who can't read	
Visitors who aren't English speakers	
Families with small children	
Teenagers	
Elders	
Visitors with limited mobility	
Visually impaired	
Hearing impaired	
Add more categories . . .	

amount of work to be done, either. Draw on past experience to estimate the amount of time needed for planning, construction, and installation. If this is your first time out, talk with colleagues at other museums. Variables that will affect the timeline include the amount of money you need to raise, the experience and skills of the Exhibit Makeover Crew, and the amount of time each team member can dedicate to the project.

At least one internationally famous museum, the Exploratorium, builds displays on the exhibit floor, in full view of the public. If you go this route, be sure to cordon off the construction zone until it's safe for visitors to enter. Even if you build behind the scenes, you may choose to mock up portions of the display in order to test ideas with visitors.

In recent years, the idea of a "soft opening" has gained popularity. The exhibit makes its public ap-

Possible Project Outcomes

Check all outcomes that might apply to you. Add outcomes specific to your museum.

How will exhibit renewal benefit visitors to the museum?

_____ Visitors feel welcome, comfortable, confident, and relaxed during the museum experience.

_____ Visitors understand key messages conveyed by exhibits.

_____ Other benefits to visitors (list)

How will exhibit renewal benefit our community?

_____ Visitors gain a deeper understanding of one or more aspects of community life.

_____ The museum becomes a more significant cultural resource for the community.

_____ The museum attracts and engages people of varied ages and backgrounds. It is a place where everybody goes.

_____ Other community benefits (list)

How will exhibit renewal benefit the museum?

_____ Increased attendance, with greater revenue potential.

_____ Favorable word-of-mouth and media publicity.

_____ Increased volunteer involvement.

_____ Increased/diversified support from individuals, businesses, corporations, foundations.

_____ Increased attention and support from government agencies.

_____ Increased ability to recruit and retain professional staff.

_____ Increased attention and recognition from professional associations and peers.

_____ Other benefits to the museum (list)

pearance piece by piece, followed by an official grand opening when all is in place.

The alternative is to set a genuine opening date and stick to it. This allows you to generate a critical mass of media attention, public interest, and attendance.

DEVELOP YOUR BUDGET

Exhibits are expensive. Design firms typically estimate the cost of a bare-bones, two-dimensional display at $150–175 per square foot. More complex exhibits, with interactives and audiovisual programs, may cost

High-Priority Outcomes

Project outcomes and measures of success for _____

Your museum's name

	Outcomes	Measure of Success
Visitors	1. 2.	
Community	1. 2.	
Museum	1. 2.	

$180–230/square foot. Top-of-the-line displays can run as high as $500/square foot. Some markup is involved, because design firms are businesses that must make a profit, but the bulk of these costs represents labor and materials.

Determine how much you want to spend on your makeover project. This is your **target budget**. Most likely, this figure will be much less than what a design firm would charge. Yet by using some or all of the following strategies, the Museum Makeover Crew can produce a worthwhile, attractive exhibit at a price you can afford.

In-kind donations of expertise and services can save a lot of money. Graphic designers, interior designers, architects, artists, and media specialists have a wealth of design and production skills. So do carpenters, painters, electricians, set designers, retail decorators, sign makers, printers, and other skilled tradespeople. Contributions of materials and equipment such as lumber, hardware, paint, and computer and audiovisual hardware and software add up to big cost savings.

When it comes to construction and installation, take a **barn-raising** approach. In consultation with experts, determine which aspects of production and installation can be done by reliable volunteers. Recruit competent supervisors to ensure the work is done right. Schedule volunteers for specific jobs at specific times. Make sure they have everything they need to get right to work and complete their task. Feed them and thank them, and they will come back.

Keep your eyes open for **partnerships** to help with aspects of your project. A service club could paint the exhibit hall or help move furniture. A local manufacturing plant might loan a mechanic to help with interactives. A high-tech firm may have computer equipment that's outmoded by their standards, but perfectly serviceable in a museum setting. They may even agree to help with maintenance and troubleshooting.

There are some **things you have to pay for**. Structural changes, electrical work, plumbing, computer programming, construction drawings, production of large-format graphics, artifact mounting, and framing

are just a few examples. The more images you use from your own collection, the less you'll need to spend on reproduction rights for images from other sources. (Think creatively: purchasing the rights to exhibit a single photo from a magazine may cost hundreds of dollars, but you can exhibit an actual copy of the magazine for free, because it's an artifact.)

SHOULD YOU HIRE A DESIGN FIRM?

After you've planned your exhibit and estimated how much time and money it will take to produce it, you may opt to turn the whole thing over to a design/fabrication firm. Shop around to find a company that respects and honors the work you've already done. For a list of qualified firms, consult a professional association such as the American Association for State and Local History, and get recommendations from museum colleagues in your region. (For more on consultants, see appendix A.)

AND MEANWHILE . . .

The next chapter focuses on important spheres of activity, such as fundraising and marketing, that fall outside the scope of the Museum Makeover Crew. Yet initiatives in these areas can make or break the success of your project. For best results, recruit supportive board members, staff, and volunteers who will help the museum make the most of your museum makeover.

Make the Most of Your Makeover

A MUSEUM MAKEOVER PROJECT HAS RIPPLE EFFECTS THAT go far beyond exhibit development. Your new look has the potential to attract new donors and new audiences. The Museum Makeover Crew will need assistance with such vital tasks as fundraising, marketing, evaluation, education, and exhibit maintenance. In this chapter you'll find basic guidelines to help board members, staff, and community volunteers plan for opening day and beyond.

FUNDRAISING

The museum's board of directors has two main roles: assuring that the museum's exhibits and programs advance the mission, and supporting the financial health of the institution. Fundraising leadership for your museum makeover project is the board's responsibility.

Finding support for a well-conceived special project is much easier than raising money for operations. An exhibition is a great opportunity to bring new donors on board. Look for prospective donors with a special interest in the subject matter of your exhibit. An exhibit is one of the most highly visible activities of a museum, providing public recognition for donors and sponsors.

You can phase your fundraising effort, seeking support in turn for planning, design, and fabrication/installation. Depending on the size and nature of your exhibit, donors might be able to "put their names" on different portions of the display. (Be sure this is done tastefully, more like a PBS tagline than a corporate-sponsored stadium or scoreboard.)

Exhibits are well-suited to attract **business sponsorships**. A major sponsor's name can appear on publicity materials, in paid advertising, and in the exhibit gallery. Performances are short-lived, while exhibits stay open for weeks or months, attracting significant numbers of visitors. This represents good value for the sponsor. When raising money from businesses and corporations, the usual cautions apply: be careful of the company you keep. Recruit sponsors whose activities and public image align with your museum's mission and values.

Individual contributors are the backbone of any fundraising program. Individuals provide about 85 percent of all funds donated to U.S. nonprofits. Consider asking your steady contributors to make an extra gift in support of this exhibition. Work with your museum's board of directors, volunteers, and staff to identify people who haven't yet contributed but who might donate for the first time to help make this exhibit idea a reality.

Foundations think like investors; they are most interested in projects that strengthen an institution. Your new exhibit adds value to the visitor experience; the makeover process builds your museum's track record and capability. Regional foundations are your most likely sources; make personal contacts, if you can, and encourage foundation staff and board members to visit your museum. Your project budget should show a balance of funding sources; foundations look for evidence that the museum is successful in attracting support from individual contributors and business sponsors. Allow plenty of lead time; it's not unusual for six months to elapse between proposal submission and receipt of funds.

An **exhibit prospectus** is a useful fundraising tool. A written description, floor plan, sample images and objects, and a project budget are essential. Concept sketches—if you can find a talented artist to draw your ideas—make your document more persuasive.

MARKETING

Getting the Word Out

Through your community-based museum makeover process, word has been getting around about the new exhibits that are going to open. Your newsletter and website have alerted **members and contributors** to the opening date and associated special events.

Identify the specific **target audiences** you want to attract, and tailor your promotional materials to each audience.

An **e-mail blast to teachers**, with a link to your website, makes it easy for educators to plan ahead, book a field trip online, and download curricular materials.

Ask board members to form a **speakers' bureau**, and schedule appearances at senior lunches, service clubs, and church socials.

Through community leaders, arrange for members of cultural groups or occupational sectors to attend **special previews and events** in association with the exhibit.

Work with your local **convention and visitors' bureau** to promote the display to conference attendees and tourists.

Plan one or more **singles events**, with music and refreshments, to attract college students and young working people.

Schedule hands-on activities and live demonstrations for weekends, to appeal to **family audiences**.

Plan for Opening Day and Beyond

A new exhibit is an opportunity to attract both first-time and repeat visitors. Make sure their experience is fun and memorable!

Advance walkthroughs for press and media can occur during the final days of installation. Contact news directors and arts editors by e-mail, and follow up by phone to schedule walkthroughs at their convenience. Give each press/media representative a hard-copy press packet with a press release, background information, and sample images; then follow up with computer files and photos in their preferred formats. Invite press and media to the public opening, as well.

Plan at least two opening celebrations: one for insiders, and one for the public at large.

Schedule an **invitation-only preview** for donors, board members, museum members, the Museum Makeover Crew, volunteer docents and greeters, and all who have contributed to the exhibit. Refreshments, a brief program, and a chance to view the finished exhibit will make this event a guaranteed success. During the program, the board president should thank all who participated.

The **public opening** is a celebration, too. Make it fun, with family-oriented activities, donated refreshments, and themed entertainment that matches the exhibit subject matter. Have lots of volunteers on hand to greet people and run the activities and refreshment tables.

Capitalize on **special events and unexpected happenings** to keep public attention focused on the exhibit. If you are bringing in a lecturer or performer from out of town, or offering a one-time workshop, issue another press release to your media contacts. A visitor may spot a long-lost relative in a photo, or bring in a family heirloom related to the exhibit content. This is an opportunity for a feature story.

Give your **business sponsors** free passes for their employees, and invite them to host an office party at the museum while the exhibit is on view. Was a **community advisory group** vital to the exhibit planning process? Invite group members to host a party at the museum for other members of their ethnic community, congregation, etc. Free admission and free use of museum facilities is a low-cost way to thank your partners.

Does your exhibit have an end date? If so, about a month before the exhibit is due to come down, let your press and media contacts know that in the coming weeks, people will have their last chance to see this very special display.

EVALUATION

Ask Visitors for Feedback

Show visitors that you welcome their comments. Place a comment book (loose-leaf notebook or ruled notepad) and pen on a table in a prominent location, with a chair that invites people to sit down and tell you what they think. In a brief, friendly label, ask visitors to share their thoughts and feelings about the exhibit, or the museum as a whole. What questions do they have? What improvements do they recommend?

Could some of the interactive opportunities be more user-friendly? Do visitors have trouble finding their way? Is a particular set of instructions confusing? Are visitors bunched up around certain displays, leaving large spaces unoccupied most of the time?

Reach out to people from the community who have limited vision, hearing, mobility, or other disabilities. Invite them to tour the museum with you. Ask them to share observations on how to make exhibits more accessible and meaningful.

Ask teachers to follow up their museum visit by asking students to evaluate the exhibits (and their museum experience in general). What was their favorite part of the museum? How could the museum be more interesting and fun for kids? If they ran the museum, what changes would they make?

In most cases, a few simple adjustments will immediately improve the experience for visitors. Improved directional signage, clearer instructions for an interactive, and rewording of a text label are examples of changes that can be made quickly and inexpensively in response to visitor feedback.

Experiment with ways to address whatever obstacles you notice. Your goal is to help visitors feel comfortable and knowledgeable, so they can participate fully in all the visitor experiences offered by the museum.

You can't please everybody; but it's well worth it to address the problems and suggestions that are most frequently mentioned by visitors. Your exhibit will improve as a result.

Learn More about Your Visitors

Exhibit evaluation studies are a useful way to find out more about current and potential target audiences for your exhibit.

Front-end evaluation techniques can be applied early in the makeover process. Focus groups and personal interviews help you find out what's in people's heads when they walk in the door. What do they already know about your subject? What do they want to know? What common misconceptions or stereotypes will you need to address?

In a **focus group**, 12–15 people with something in common (e.g., educators, elders, museum members, nonmuseumgoers) engage in conversation sparked by a series of open-ended questions. This is a useful way to learn how different segments of your audience may approach the exhibit content. For best results, use an experienced facilitator; and be prepared to pay extra for a transcript of the proceedings.

A **personal interview with a questionnaire** gives you more information in a shorter time than any other method. It's important to select interview subjects randomly; otherwise the interviewer's biases will skew the study. Hire an experienced evaluator to develop the questionnaire, train the interviewers, and analyze the results.

If you decide to do evaluation studies yourself, it's vital to get some training. Watch for a workshop, conference session, or online class on evaluation. An experienced evaluator at a larger museum, or an evaluation consultant, may be willing to coach your staff in evaluation methods and techniques. An ongoing evaluation program builds a body of knowledge about your visitors, creating an invaluable resource for exhibit and program planning.

EDUCATIONAL MATERIALS AND PROGRAMS

During the exhibit planning process, you inevitably come up with more great ideas and interesting stories than you can squeeze into the finished product. Some of these ideas may contain the kernel of programs and materials that will enrich visitors' experience of the exhibit.

Basic types of **educational materials** include a self-guided tour, pre- and post-visit materials for teachers, activities for families with young children, and one or more features on your museum's website.

Some examples of **educational programs** are lectures, roundtables, and exhibit tours by people who know about the subject matter (scholars, elders, members of a cultural group, etc.); film showings; musical and dramatic performances; and demonstrations and workshops related to the exhibit subject matter.

Like exhibits, educational programs are the result of **careful planning**. Think about the audiences you want to reach, and the educational objectives for various types of programs. Get teachers, parents, and children involved in designing and testing materials.

Find the **most qualified resource people** to lead programs; ask for references and check them. (People who work with children need to pass a police background check.) Seek funding for educational programming, so that you can pay honoraria and expenses.

For ideas about developing educational programs, explore the websites of larger museums, and talk to museum educators in your region. Watch for preconference workshops on education at state and regional museum association meetings. Browse the Internet for online course offerings on museum education.

KEEP YOUR EXHIBITS FRESH

Cleaning and Maintenance

Visitors who are excited and involved will leave evidence of their enthusiasm all over your exhibits, most visibly in the form of fingerprints and noseprints. Dust and grime accumulate in museum exhibits, just as they do at home. To keep your exhibit fresh, it's important to establish and follow daily, weekly, monthly, and annual cleaning routines.

Stock a hand carrier with cleaning supplies and equipment. These should include soft rags, lint-free microfiber towels, nonscratch sponges, paper towels, biodegradable cleaner (e.g., Simple Green), disinfectant (e.g., Lysol), a feather duster, and plastic cleaner for plexi surfaces. You'll also need an industrial-strength vacuum cleaner and a sturdy mop and bucket combination.

DAILY

- Walk through the exhibits.
- Make sure everything is in order. Be alert to the possibility that someone may have tampered with an exhibit case. If you notice that an object is missing, check first to see if a staff member has removed it (for photography, conservation, etc.). If not, call the police to report a theft.
- Remove graffiti, glass etching, and other signs of vandalism immediately, to discourage copycats.
- Pick up litter, empty wastebaskets, replace supplies, mop the bathroom, clean the toilets and sinks. If

your visitors include small children, scrub washable props in hot soapy water. Clean touchable surfaces with disinfectant.
- Vacuum carpets and wash floors as needed (this depends on your visitor traffic and whether someone threw up on the floor).

WEEKLY

- Vacuum carpets thoroughly.
- Dust exposed surfaces.
- Scrub doors and other high-touch surfaces to remove grime.
- Clean all touchable surfaces with disinfectant.
- Deep clean the bathrooms.
- Wash floors.
- Remove any damaged or nonworking interactive exhibits from the floor.

MONTHLY

- Dust inside cases and wash inside glass surfaces as needed.
- Replace labels that have become torn or faded.

ANNUALLY

- Paint interior walls in high-traffic areas.
- Clean objects in cases. Hire a conservator to teach staff and volunteers how to do this safely.
- Repair and renovate exhibits. Replace panels that look beat-up, faded, or damaged.

Repairs

The more popular and accessible your exhibit is, the more likely you are to need to do a little repair work now and then. Consider it a sign of success! Of course you've been careful to keep your most precious and fragile objects out of harm's way, but the interactives and many touchable parts of the exhibit may suffer from overuse or simple malfunctions.

Interactives that don't work: If removal will be disruptive or impractical, post a sign so visitors don't get frustrated trying to use the device. If a back-up is available, put it out as quickly as possible. If you are leaving a visible "hole" in the exhibit, a small, typeset sign can explain the gap in content while repairs are being done.

Damaged walls or panels: Keep small jars of your accent and wall color paints on hand for quick touch ups. Larger areas of damage may require closing the gallery for sanding, painting, or replacement of broken elements. Remember, your ladders and tools are a

safety hazard for children and anyone with limited sight or mobility, so it is better to partition off the area while it is being repaired.

Sometimes things just fall off; if you have many mounted objects, it is not unusual for something to mysteriously "break loose" from its place. Perhaps the mounting material wasn't strong enough for the weight, or someone bumped the case and the contents shifted. Check the placement of your objects regularly, and remount anything that has moved out of place.

If there are problem areas where repairs seem to be needed frequently, study the traffic pattern and use of the space carefully. You may need to adjust placement, find a sturdier material, or eliminate a piece altogether if it is not compatible with visitor traffic or usage.

Changeouts

Remember all those facts, objects, and images that didn't make it into the final display? Consider making part of your exhibit a rotating space that changes every few months, or seasonally, or as often as is practical for your team. Changeouts could be as simple as replacing some specimens in a case, or as complex as redesigning strategic cases or areas of the exhibit with new messages and concepts.

In a small exhibit, a section of text and images might be replaced on a regular schedule. Perhaps you have several antique automobiles in the garage but only room for one on the floor. Repeat visitors will be drawn to the "new" piece and will appreciate the depth of your collection.

In a large exhibit hall, changeouts allow the repeat visitor to experience some variety without a complete overhaul of the space. A changeout may also allow you to address different audiences or topics that may be relevant during a particular time. An example of this might be a historic house that has seasonal displays, or a natural history museum that features wildflower identification in the spring.

Think of your exhibits as a work in progress, and welcome opportunities to improve or expand on your team's hard work. These small updates will keep your exhibits fresh for years to come!

VITAL SIGNS

Keep taking the pulse of your museum. Are exhibits, programs, and services working for visitors? The Visitor's Bill of Rights, a checklist of important human needs, allows members of the Museum Makeover Crew to assess the museum's vital signs.

The Visitor's Bill of Rights

Legendary exhibit developer and writer Judy Rand (whose engaging labels at the Monterey Bay Aquarium took interpretive writing to a whole new level) made this inspiring presentation at a 1995 meeting of the Visitor Studies Association in Estes Park, Colorado. Keep these precepts in mind as you plan your exhibits; use them to evaluate visitor services and the museum as a whole. Think of the Visitor's Bill of Rights as a set of goals for improving your visitors' experience, over time.

- **Comfort:** "Meet my basic needs." Visitors need fast, easy, obvious access to clean, safe, barrier-free restrooms, fountains, food, baby-changing tables, and plenty of seating. They also need full access to exhibits.
- **Orientation:** "Make it easy for me to find my way around." Visitors need to make sense of their surroundings. Clear signs and well-planned spaces help them know what to expect, where to go, and how to get there.
- **Welcome/belonging:** "Make me feel welcome." Friendly staff make visitors feel more at ease. If visitors see themselves represented in exhibits and programs and on the staff, they'll feel more like they belong.
- **Enjoyment:** "I want to have fun." Visitors want to have a good time. If they run into barriers (like broken exhibits, activities they can't relate to, intimidating labels), they can feel frustrated, bored, or confused.
- **Socializing:** "I came to spend time with my family and friends." Visitors come for a social outing with family and friends (or to connect with society at large). They expect to talk, interact, and share the experience; exhibits can set the stage for this.
- **Respect:** "Accept me for who I am and what I know." Visitors want to be accepted at their own level of knowledge and interest. They don't want exhibits, labels, or staff to exclude them, patronize them, or make them feel dumb.
- **Communication:** "Help me understand, and let me talk too." Visitors need accuracy, honesty, and clear communication from labels, programs, staff, and volunteers. They want to ask questions and express differing points of view.
- **Learning:** "I want to learn something new." Visitors come (and bring the kids) "to learn something new," but they learn in different ways. It's important to learn how visitors learn, and access their knowledge and interests. Controlling distractions (like crowds, noise, and information overload) helps them too.

- **Choice and control:** "Let me choose; give me some control." Visitors need some autonomy: freedom to choose, and exert some control, touching and getting close to whatever they can. They need to use their bodies and move around freely.
- **Challenge and confidence:** "Give me a challenge I know I can handle." Visitors want to succeed. A task that's too easy bores them; too hard makes them anxious. Providing a wide variety of experiences will match their wide range of skills.
- **Revitalization:** "Help me leave refreshed, restored." When visitors are focused, fully engaged, and enjoying themselves, time flies and they feel refreshed: a "flow" experience that exhibits can aim to create.

Once begun, the museum makeover process never ends. Board, staff, and volunteers are engaged in creativity, innovation, and reflection aimed at enriching the museum experience for visitors. Your museum may be well on the way to becoming a model and an inspiration. On behalf of community members and museum professionals, thank you!

Appendix A offers tools and resources that may come in handy at any level of makeover: single-case to museum-wide. You'll find an introduction to professional associations, an annotated bibliography, and suggestions about the effective use of consultants.

Tools and Resources

THE EXHIBIT/MUSEUM MAKEOVER PROCESS IS A WONDERFUL way to make new friends for the museum. In the course of your makeover project, you'll come up with questions you can't answer and problems you can't solve. Reach out—to people in your community and region, and to museum professionals in your state and beyond. You'll be surprised how many will be glad to lend a hand and share their expertise.

LOCAL TALENT

Your community includes professionals, people skilled in various trades, and serious amateurs with a wealth of knowledge. Find out who is interested in your subject matter or the museum, and ask them to help. A retired engineer may find a new calling as an exhibit builder. A high school art teacher may have time in the summer to assist with design and installation. When you approach people for volunteer assistance, be specific about your need. Set up your project to make it easy for each volunteer to contribute a tangible, discrete piece of the final product. Be sure to thank each volunteer in a public and visible way.

PROFESSIONAL ASSOCIATIONS

The museum field is very well organized. Many cities, and most states, have museum associations that meet regularly. There are also regional museum associations in all parts of the United States, each with an annual conference accessible to museums in multiple states. If you're not already involved with your local, state, or regional museum association, ask a museum colleague at a larger institution to point you in the right direction.

The leading national museum associations are the American Association of Museums (www.aam-us.org), the American Association for State and Local History (www.aaslh.org), and the Association of Science-Technology Centers (www.astc.org).

PUBLICATIONS

- *Dimensions* is published bimonthly by the Association of Science-Technology Centers, www.astc.org.
- *Exhibitionist* is an occasional newsletter published by the National Association for Museum Exhibition (NAME), a standing committee of the American Association of Museums. Information at www.aam-us.org.
- *History News* is the bimonthly publication of the American Association for State and Local History, www.aaslh.org. AASLH also publishes excellent Technical Leaflets; these and other publications can be purchased through their online bookstore.
- *Museum News* is published bimonthly by the American Association of Museums, www.aam-us.org.

LISTSERV

The granddaddy of museum listservs is Museum-L. You can ask anything related to museums on Museum-L, and you will almost always get an answer. To view the archives and sign on, go to http://home.ease.lsoft.com/archives/museum-l.html.

OTHER MUSEUMS

Some of the nation's leading, award-winning museums are small institutions. To learn about the history of community-based institutions that have done it right, take a look at the websites of Seattle's Wing Luke Asian Museum, the Pratt Museum in Homer, Alaska, and the Tenement Museum in New York City. (These are just examples; keep an eye out for other high-quality small museums.)

Through your state and regional museum associations, find out about exemplary small museums close to home. Visit them; get to know their staffs and volunteers. Let them guide and inspire you as you focus on what's unique and special about *your* museum.

If Makeover Crew members have opportunities to travel, ask them to record their museum experiences photographically and in writing. Join state, regional, and national museum associations, read their publications, and attend their conferences. Explore museums' websites. Gather ideas, inspiration, and cautionary tales.

CONSULTANTS

Your makeover project may inspire you to undertake something larger: a new building, entirely new exhibits,

or an extensive evaluation program. If you *think* you need expert advice, you probably do. Most professionals are willing to provide a limited amount of consulting for free; but they have to earn a living. Expect to pay them for their expertise.

Architects; exhibit planners, designers, and fabricators; and evaluators provide unique and valuable services.

If you choose to work with consultants on a makeover project, here are some ways to help ensure that your exhibit and museum development process will go smoothly:

- Recruit a planning committee (like the Exhibit Makeover Crew) of dedicated people who are in it for the long haul. Planning, design, and construction can take as long as two or three years, depending on the scope of the project. Committee turnover, missed meetings, blown deadlines, etc., are bad for the project and bad for morale. Try to recruit a committee of people who care.
- Use a formal process to screen potential consultants. Often, a request for qualifications (RFQ) can help you narrow the field, so that you issue your request for proposal (RFP) to prescreened, qualified firms. If you are unfamiliar with this process, ask colleagues at established museums to share examples of RFQs and RFPs with you.
- If appropriate, use independent consultants to help with early visioning. If major fundraising is still in your future, consider hiring a design firm or an independent consultant to create an interpretive master plan. This can be an invaluable fundraising tool.
- If you are planning a new building or an extensive building remodel, you will need an architect. It's best to hire the architect and the exhibit design firm at the same time. The building design should match the scope and nature of the exhibits, and vice versa.
- It is generally most cost-effective to have exhibits designed and built by the same firm.
- Your consultants will provide you with a series of drafts of exhibit plans and concept designs for exhibits and the building. As the client, your responsibility is to review each draft completely and thoroughly, in timely fashion. Each time you sign off on a milestone document, be aware that subsequent changes become more difficult to make, and therefore more costly.
- Build changeability and flexibility into your exhibit design. It's important to be able to keep your exhibit up to date. Display cases should be secure, but accessible to staff so you can rotate objects and keep them clean. Thanks to computer graphics, it's now relatively easy and inexpensive to redo entire panels.
- Avoid trendy and fashionable designs and typefaces that will quickly go out of date. And don't use brand-new technology. The first generation of any innovative technology can be expensive and full of bugs. Use proven technology that can stand up to heavy use by museum visitors.
- Remember that an extensive makeover project will need your full attention. Don't think of it as a sideline, but as a second part-time job that will sometimes be full-time.

RECOMMENDED BOOKS

These reference works have stood the test of time. For a continually updated list of publications on all aspects of museums, visit the American Association of Museums' online bookstore at www.aam-us.org. And ask your museum colleagues to recommend books they've found useful.

THEORY INTO PRACTICE

Gail Anderson, ed., *Museum Mission Statements: Building a Distinct Identity*. Washington, D.C.: American Association of Museums, 2000. Combining theory with practice, this book shows how to develop a new mission statement or improve upon an old one.

Sandra L. Beckwith, *Publicity for Nonprofits*. Chicago: Kaplan, 2006. A useful guide to affordable marketing of museum exhibits and programs.

Graham Black, *The Engaging Museum: Developing Museums for Visitor Involvement*. New York: Routledge, 2005. A comprehensive, useful introduction to visitor-focused institutional and interpretive planning.

Barry Lord and Gail Dexter Lord, eds., *The Manual of Museum Exhibitions*. Walnut Creek, Calif.: AltaMira Press, 2002. A comprehensive overview of planning and design considerations, with contributions from a variety of specialists.

Kathleen McLean, *Planning for People in Museum Exhibitions*. Washington, D.C.: Association of Science-Technology Centers, 1993. Unsurpassed as a general introduction to exhibit planning. Kathleen McLean is an internationally recognized exhibit planner and designer.

Bonnie Pitman-Gelles, *Museums, Magic, and Children: Youth Education in Museums*. Washington, D.C.: Association of Science-Technology Centers, 1982. Out of print, unfortunately, but you may find a used copy through an online search. Includes an invaluable checklist on how to start a museum.

Beverly Serrell, *Exhibit Labels: An Interpretive Approach*. Walnut Creek, Calif.: AltaMira Press, 1996. The classic

book on how to write effective exhibit labels. Accessible, interesting, and very helpful.

Stephanie Weaver, *Creating Great Visitor Experiences: A Guide for Museums, Parks, Zoos, Gardens, and Libraries.* Walnut Creek, Calif.: Left Coast Press, 2007. Structured steps for making your museum more welcoming and rewarding for all.

MORE ABOUT MUSEUMS

Gail Anderson, ed., *Reinventing the Museum: Historical and Contemporary Perspectives on the Paradigm Shift.* Walnut Creek, Calif.: AltaMira Press, 2004. A well-documented and readable chronicle of commentary on American museums.

Lynn Cooke and Peter Wollen, eds., *Visual Display: Culture Beyond Appearances.* Seattle: Bay Press, 1995. Through historical and contemporary examples, articles showcase the exhibit designer's role in presenting topics as diverse as technology, politics, and natural history. Are there hidden agendas in the choices we make for displays?

John Elsner and Roger Cardinal, eds., *The Cultures of Collecting.* Cambridge, Mass.: Harvard University Press, 1994. An exploration of the psychological and social motivations behind the collecting of objects.

John H. Falk and Lynn D. Dierking, *The Museum Experience.* Washington, D.C.: Whalesback Books, 1992. How people learn in museums—the visitor's perspective.

Amy Henderson and Adrienne L. Kaepler, eds., *Exhibiting Dilemmas: Issues of Representation at the Smithsonian.* Washington, D.C.: Smithsonian Institution Press, 1997. Essays by Smithsonian staff trace the rethinking and representation of history and culture. From ethnographic displays to the Woolworth lunch counter of the civil rights movement, a wonderful insight into the issues and choices exhibit designers and curators face.

Ivan Karp and Steven D. Lavine, eds., *Exhibiting Cultures: The Poetics and Politics of Museum Display.* Washington, D.C.: Smithsonian Institution Press, 1991. A great gathering of perspectives on the changing philosophies of museum exhibit curation and design. Especially valuable for those with multicultural collections.

Susan M. Pearce, *Museums, Objects, and Collections.* Washington, D.C.: Smithsonian Institution Press, 1992. A curator's perspective on the ways that objects develop meaning over time and are subject to interpretation based on their context. A solid overview for anyone interested in postmodernism and the challenges it brings to museums and displays.

Marjorie Schwarzer, *Riches, Rivals, and Radicals: 100 Years of Museums in America.* Washington, D.C.: American Association of Museums, 2006. A compelling history of museums in the United States, by a knowledgeable and insightful scholar. Inspiring, entertaining, and enlightening.

Stephen E. Weil, *A Cabinet of Curiosities: Inquiries into Museums and Their Practices.* Washington, D.C.: Smithsonian Institution Press, 1995. From Weil's intense scrutiny of the assumptions that museums make regarding their role and value in our culture to cautionary tales of ethical and financial dilemmas, this is a rich resource for discussion.

Stephen E. Weil, *Rethinking the Museum and Other Meditations.* Washington, D.C.: Smithsonian Institution Press, 1990. Weil's succinct, penetrating essays question assumptions and stimulate thought. Very rewarding reading.

W. Richard West, ed., *The Changing Presentation of the American Indian: Museums and Native Cultures.* Seattle: University of Washington Press, 2000. Native people are part of the history of every place in North America. Your community is no exception. Rick West (Cheyenne), founding director of the National Museum of the American Indian, knows whereof he writes.

DESIGN

Steven Heller and Seymour Chwast, *Graphic Style: From Victorian to Digital.* New York: Harry N. Abrams, 2001. If you are trying to evoke a particular period in time, this visual history can provide valuable references for classic typography, color, and style.

Joyce Rutter Kaye, *Design Basics: Ideas and Inspiration for Working with Layout, Type, and Color in Graphic Design.* Gloucester, Mass.: Rockport, 2002. If you'd like to shake things up with eclectic, edgy style ideas for your first design meeting, put this book on the table. Samples of anything and everything printed reflect the trendiest uses of color, type, texture, photography, illustration, cutouts, assemblage, and more.

Jim Krause, *Design Basics Index.* Cincinnati: HOW Books, 2004. Krause writes for the print designer but offers lots of great ideas for combining type, images, color, and composition. *DBI* blends visual examples of basic how-tos for the beginner with enough excitement for the veteran.

Edward R. Tufte, *Envisioning Information.* Cheshire, Conn.: Graphics Press, 1990.

Edward R. Tufte, *The Visual Display of Quantitative Information.* Cheshire, Conn.: Graphics Press, 1983. Tufte's books set the standard for clear, concise presentation of complex data in graphic formats.

INSPIRATION

National Geographic, passim, for examples of effective captions that draw your attention to the images and motivate you to read the articles.

William Strunk Jr. and E. B. White, *The Elements of Style.* New York: Longman, 2000. This book is an invaluable reminder of the basic rules of grammar, usage, and style. It's also fun to read.

Freeman Tilden, *Interpreting Our Heritage.* Chapel Hill: University of North Carolina Press, 1977. Tilden invented

the term "interpretation" as a way to understand the unique educational role of national parks, museums, and other informal spaces where learning occurs.

Alfred North Whitehead, "The Aims of Education" and "The Rhythm of Education," in *The Aims of Education*. New York: Free Press, 1967. Whitehead didn't have museums in mind when he wrote these essays, but his ideas about the stages of learning—Romance, Precision, Generalization—are useful guides to exhibit development.

ADDITIONAL USEFUL REFERENCES

Use this space to note other books and articles that you have found useful during the makeover process.

What Is Your Museum's Purpose?

FINDING THE REAL YOU

In response to the question "What is our museum's purpose?" you might automatically reach for your institution's mission statement. But for now, keep the mission statement in reserve, and go back to your institutional roots.

- After you examine your museum's history to understand its origins, you'll explore how the museum's purpose has changed through time. (Worksheet A)

- Then you'll assess what role your museum plays in the community now, and determine what role you would like it to play. (Worksheets B and C)
- You'll evaluate (and, if necessary, modify) your current mission statement in light of these new understandings. (Worksheet D)
- Finally, you'll shape your hopes and dreams into a vision of the museum's future. (Worksheet E)

Honoring Our Museum's Past: Who Are We?

As a first step in planning, learn as much as you can about your museum's history. Use this worksheet as a guide. Don't be satisfied with hearsay; members of the Makeover Crew will know some of the answers to these questions, but there's always more to learn.

Do the research that will help you understand the motivations, personalities, controversies, struggles, and triumphs that have made your museum what it is today.

To find the information you seek, draw upon documents and sources such as:

- Articles of incorporation.
- Early correspondence, fundraising letters, publications, files.
- Stories in back issues of your local newspaper.
- Personal knowledge of volunteers, staff, and community members.

(If your Makeover Crew is starting a new institution, use this exercise as a way to recognize the people, ideas, values, and controversies that have shaped your plans so far.)

History of _____
 [your museum's name]

1. What was the original purpose of your museum?

2. Who started the museum?

3. What values, needs, and hopes motivated the museum's original founders?

4. Who are the key people who have helped to shape and guide the museum since it was founded?

5. What notable successes has the museum achieved?

6. What obstacles has the museum overcome?

7. Has the museum's purpose changed over time? (See Question 1.) If yes, describe the current purpose.

The Museum's Community Role: We Make a Difference

Whatever your history and your subject matter focus, your museum as an institution plays a distinctive role in the drama of community life. How do community members perceive your museum? Use this worksheet to guide your assessment.

Community Role of _____

 [your museum's name]

Review each description as it might apply to your museum today. Check the descriptions that you think best match how your community *now* views your museum. Rank order each description on a scale of 1 to 5 (1 = perfect match; 5 = not at all like us).

Add categories and descriptions that better define your institution. Make this worksheet your own.

_____ **Visitor attraction:** The museum is the "front porch" of the community, welcoming visitors and giving them an overview of what's special and unique about this place.

_____ **Catalyst for change:** The museum exists to deliver a message that will encourage people to think differently about their relationship to others or to the world.

_____ **Center of creativity:** The museum engages visitors in activities where they make and do things. Visitors, rather than the museum, determine the outcomes.

_____ **Memory bank:** The museum displays aspects of the history of a place, person, cultural tradition, etc.

_____ **Storyteller:** The museum interprets the history of a place, person, cultural tradition, etc., in ways that relate the past to the present—and even to the future.

_____ **Attic:** The museum preserves objects and images that would otherwise have been discarded.

_____ **Treasure trove:** The museum preserves valuable, meaningful, rare, and unusual objects and images.

_____ **Shrine/hall of fame:** The museum honors a particular group or individual and assumes visitors have a built-in interest in this topic.

_____ **Exclusive club:** Although open to the public, the museum is primarily aimed at people with special interests in and knowledge of the topic.

After the Makeover Crew has answered these questions, check your accuracy by doing some informal research. Ask a cross-section of people you know about the museum. (Try to include a range of ages, educational levels, and economic backgrounds.) Request their honest assessment. "What have you heard about the museum?" is a good conversation-starter. Don't comment, criticize, or defend. Just listen, and make notes later.

Then revisit the worksheet as a team and ask again, how do community members view the museum?

The Museum's Intended Role in the Community

What roles could your museum play in the community? What roles would you like the museum to play? If you're not satisfied with the status quo, now is the time to rethink, rewrite, and create a modified or brand-new community role for your institution.

Intended community role of _____
[**your museum's name**]

Drawing on the category descriptions in Worksheet 1B, what role(s) do you think your museum could and should play in your community?

Describe this role in a short paragraph.

The Museum's Mission: Why Do We Exist?

Now it's time to revisit the museum's mission. In light of your institutional history, your current purpose, and your desired community role, do you need to modify the museum's mission statement? This exercise will help you evaluate your museum's mission in light of the institution's history and community role.

1. What is our museum's most recently approved mission statement?

2. Does our mission statement reflect changes in the museum's purpose? (See Worksheet 1A.)

3. Does our mission statement reflect the museum's role in the community? (See Worksheets 1B and 1C.)

4. If you answered YES to questions 2 and 3, you're ready to move ahead with exhibit planning.

5. If you answered NO to either question 2 or 3, or if the museum doesn't have a mission statement, ask the museum's board of directors to draft a working statement of purpose. For best results, respected community leaders should be involved, as well as museum insiders. Once this draft is in place, the Makeover Crew can proceed with exhibit planning. The board can continue their work on the mission statement as a parallel activity.

For help with your museum's mission statement, see Gail Anderson, *Museum Mission Statements: Building a Distinct Identity* (American Association of Museums, 1998), available through the AAM Bookstore, www.aam-us.org.

The Museum's Vision: The Dream We Share

Begin with your mission or draft statement of purpose. Those words summarize why you exist, who you serve, and what makes your institution unique. The mission statement is the heart and soul of the museum's identity.

Mission Statement or Draft Purpose Statement of _____
 [name of your museum]

Given the values and intentions expressed in your mission statement, what are your hopes and dreams for the museum? How can you summarize the museum's potential to become a valued community, regional, national, or even global resource?

Exhibit renewal grows out of a desire to move beyond business as usual and aim for growth, rejuvenation, or rebirth. Often the impetus for change takes a visionary form, rallying diverse individuals around a shared dream.

We have all known people whose quiet persistence, resilience, and courage enabled them to overcome many setbacks and finally realize a long-cherished dream.

We've also known charismatic "builders" whose gifts of persuasion and rhetoric turned dreams into reality but who could not necessarily build support or leadership to sustain their creation over the long haul.

Make your vision as explicit as possible. Dream big—but don't get ahead of your ability to deliver the time, money, and energy that will be needed to fulfill your dream. Seek a vision that's practical enough to inform and guide everything you do. This will give your museum the rare, unmistakable hallmarks of originality and quality, creating an unforgettable experience for your visitors.

Vision Statement of _____
 [name of your museum]

Ask the museum's board of directors to consider, review, and approve a working vision statement. As you move forward with the exhibit planning process, incorporate any changes that result from the board review process.

Subject Index

Worksheets Index

About the Authors

Alice Parman fell in love with museums as a child, and has worked in and around them since 1972. She was education department chair at Chicago's Field Museum, director of two museums in Oregon, and planner/writer for an exhibit design firm. An interpretive planning consultant since 2003, she works nationally from her home in Eugene, Oregon. More information at www.aparman.com.

Jeffrey Jane Flowers began her display career dressing retail store windows while attending the Maryland Institute College of Art. Her expertise in graphic design and marketing combined with a hands-on approach to construction and fabrication allows her to work with clients on small budgets from initial concept to exhibit opening. She currently works for the City of Eugene, Oregon, as a graphic and exhibit designer and stormwater education specialist.